IMAGES
of America

SOUTHAMPTON
COUNTY

IMAGES
of America

SOUTHAMPTON
COUNTY

Terry Miller

ARCADIA
PUBLISHING

Published by Arcadia Publishing
Charleston SC, Chicago IL, Portsmouth NH, San Francisco CA

Printed in the United States of America

Library of Congress Control Number: 2008940505

For all general information contact Arcadia Publishing at:
Telephone 843-853-2070
Fax 843-853-0044
E-mail sales@arcadiapublishing.com
For customer service and orders:
Toll-Free 1-888-313-2665

Visit us on the Internet at www.arcadiapublishing.com

To Maggie Fisher (1882–1962) and women like her, who nurture generations of Southampton families and still have energy and love to give to their own churches and children.

CONTENTS

Acknowledgments

I am humbled by the confidence that Arcadia Publishing, especially my editor, Brooksi Hudson, has placed in me to produce books that I hope are valuable and enduring.

The Walter Cecil Rawls Memorial Library and the Southampton County Agriculture and Forestry Museum and Heritage Village are storehouses of information and carry artifacts that cannot be missed in this community. Their willingness to share their collections with me has been invaluable to the success of this project. Their leadership especially has given me information, contacts, and encouragement, and for that I will be forever grateful.

Richard Francis, clerk of Southampton County, is a resource for the ages because of his enthusiasm for history and his passion for maintaining important records. Others who helped me on this journey were Mertle and Obadiah Claud; Harvey Smith, Maryland Pope, and Carl Faison, all of Shiloh Baptist Church; Mayor Richard Edwards of Boykins; and the ever-elegant Lynette Allston.

A special thank you is extended to the men and women who allowed me to follow them home after their church services. John and Doris Miller, David Turner, and Marie Turner offered some of the best examples of hospitality I could have hoped for. Ira "Pete" Barham reminded me of how infrequently people visit one another. I was warmed by his willingness to share some Capron history. Roy and Kitty Lassiter were terrific, and John and Margaret Wilroy are walking examples of the depth of affection one can have for that place called home. Warm regards are extended to Elvin Vaughan and Beatrice Magette for the wealth of history in their memories. Everyone I came across for this project made my time richly rewarding.

My enduring thanks goes to my family: Robert Holland, Pia, parents, and those extensions of my life who call me regularly and always encourage me to do my best work—even in difficult times.

INTRODUCTION

Many books have been written about Southampton County. This book is different; its focus is on ordinary people through extraordinary times in Southampton County, Virginia. The subjects featured were all born before 1920 and were chosen in an effort to capture the early struggles experienced building cities, making a living, and raising children in a rural environment. Unfortunately, this book does not cover all events, people, and places. It is rather a representation of a community at a particular time in history.

This book is divided into four chapters. The first, titled "Survival and Honor," is all too brief about the county's Native American heritage; law and order in the context of the soul of the slave Nat, often called Nat Turner; and the role of the men who served in the military.

Chapter two, titled "Sustenance," is about different kinds of work, particularly farming. Chapter three is an overview of education, and it ends with a famous person who visited the area often to give inspiration.

The last chapter honors joy in little things—faces, talents, and faith. The community of Southampton County has changed greatly over the years, for better and worse. This nostalgic journey remembers the uplifting values that are resident throughout the county.

One

SURVIVAL AND HONOR

Different communities of Native Americans inhabited the land when settlers arrived and made what is now called Southampton County their home, too. Research now tells us that 10 confirmed lines of Native American ancestry have been established by the Nottoway Indian Tribe of Virginia, Inc. Through the instinct of survival, Native Americans assimilated the best way they knew how—through marriage to whites and African Americans. Both free and enslaved African Americans, again through the instinct of survival, made their way through decades of degradation often by succumbing to others. Thus no discussion of people in Southampton County is worthwhile without acknowledging that ethnicities are intertwined. Not even the 1924 Race Reconciliation Act could prevent or erase what was obviously true: bodies collided both violently and lovingly throughout time, which produced a community of people who have a variety of skin colors and who share surnames across racial lines.

One must acknowledge that there is a difference between pre-1831 Southampton and post-1831 Southampton because of the infamous slave insurrection led by the slave Nat Turner. Before 1831, the influence of Quakers could not be understated. They were instrumental in creating an open society where slaves and former slaves could move freely from farm to farm without fear. Many slaves were made free men and women because of the Quakers' unwavering belief in and discussions about the merits of freedom for all people. After the insurrection, whites retaliated against people of color in ways that ensured reverberations to this day. It was not fear that drove and protected them, it was the instinct to survive—and is still.

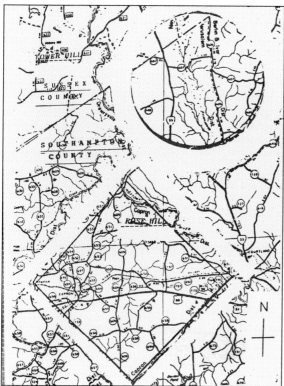

There were two reservations established for Native Americans in the early 1800s, and they were termed the "circle" and the "square" tracts. This map shows the locations of those original reservations in old Jerusalem, Virginia. (Courtesy Walter Cecil Rawls Memorial Library.)

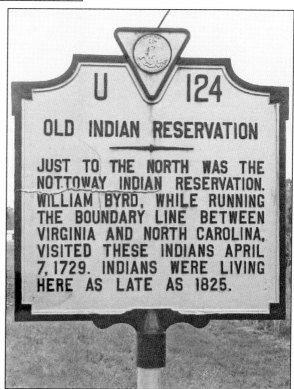

The original Native American reservations are honored by this informational signpost on Highway 35 South in old Jerusalem (now Courtland), Virginia. (Photograph by Terry Miller.)

The Commonwealth of Virginia,

To all to whom these presents shall come, Greeting:

KNOW YE, *That our Governor, on recommendation from the court of the county of* Southampton *hath, with advice of our Council of State, constituted and appointed* James D. Arsonburg, Peter Booth, Thomas Pretlow, John Thomas, Benjamin Turner *and* John Blunt,

Justices of the Peace, *in and for the said county*

in addition to those now holding that office, with authority as well to execute within the limits of the said county, the other duties of the said office, prescribed by law, as to be of any court to be held for the said county.

IN testimony whereof, these our letters are sealed with the seal of the Commonwealth and made patent. **Witness,** *Wilson C. Nicholas Esquire, our said Governor, at Richmond, on the* twenty seventh *day of* July *in the year of our Lord one thousand eight hundred and* sixteen *and the Commonwealth the* forty first.

W. C. Nicholas

Southampton County has the distinction of having some of the earliest official documents in the commonwealth. This 1816 document for justices of the peace is important for the names on it, especially Benjamin Turner. If history is correct, he purchased a slave woman that he named Nancy who, when coupled with "the son of old Bridget," birthed the man history calls Nat Turner. (Courtesy Southampton County Courthouse.)

THE COMMONWEALTH OF VIRGINIA,

To all to whom these present Letters shall come, Greeting:

KNOW YE, That our Governor, on recommendation from the Court of the County of *Southampton* hath, with the advice of our Council of State, constituted and appointed

James Trezvant, Richard Urquhart, Oris A. Browne, Alexander P. Peete, Joseph T. Claud, John Nicholson, Alexander Myrick & Thomas R. Gray

JUSTICES OF THE PEACE, in and for the said County of *Southampton* in addition to those now holding that office, with authority as well to execute within the limits of the said County, the other duties of the said office, prescribed by law, as to be of any Court to be held for the said County.

In testimony whereof, these our Letters are sealed with the Seal of the Commonwealth and made patent,

WITNESS, *William B. Giles* Esq. our said Governor, at Richmond, on the *eighth* day of *December* in the year of our Lord one thousand eight hundred and *twenty seven* and of the Commonwealth the *fifty second*

This 1827 certification record for new justices of the peace shows the name Thomas R. Gray. Previously he served as county overseer of the poor and as commissioner for Indian land. He taught himself law and was subsequently certified, but his fortunes were so low that he bought an inn to make extra income. Gray is most noted for penning *Confessions of Nat Turner*. (Courtesy Southampton County Courthouse.)

John Floyd (1783–1837) was an important governor in early Virginia history. He was the son of John Floyd Sr., a surveyor who freed Daniel Boone's captured children from Native Americans. John Floyd Jr. received his medical degree from the University of Pennsylvania and later served as Virginia's governor from 1830 to 1834. (Courtesy C. H. Ambler, *The Life and Diary of John Floyd, Governor of Virginia*.)

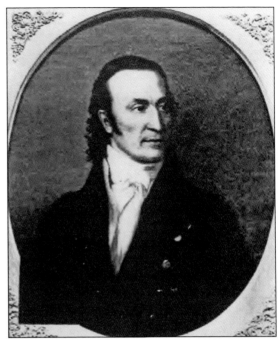

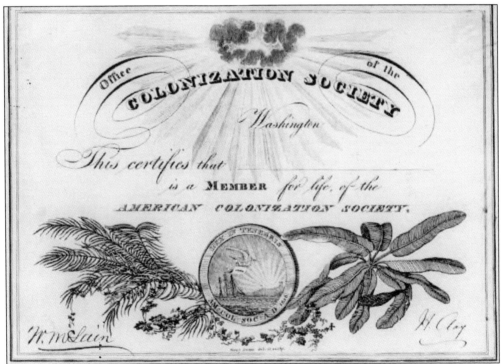

The American Colonization Society (ACS) was formed in 1816–1817 in Washington, D.C., and was active in Southampton County. The society's mission was to send blacks to a new colony in Liberia, because its members believed blacks would never be accepted fully into the new American culture and into its political and social life. As a fund-raiser, the society sold life memberships for $30 and issued certificates. (Courtesy Library of Congress.)

= American colonization society =

INFORMATION

ABOUT GOING TO LIBERIA.

THINGS WHICH EVERY EMIGRANT TO LIBERIA OUGHT TO KNOW.

COMMON OBJECTIONS

TO GOING TO LIBERIA ANSWERED,

REPLY

TO CERTAIN CAVILINGS AGAINST COLONIZATION.

&c., &c.

WASHINGTON:

C. ALEXANDER, PRINTER,

NEAR WAR AND NAVY DEPARTMENTS.

1848.

Marketing material was produced by the American Colonization Society to inform former slaves of the benefits of moving to Liberia. The information also discussed African climate, health conditions, and daily living. The issue here was that the overwhelming majority of free blacks could not read. (Courtesy Library of Congress.)

The Commonwealth of Virginia,

TO ALL WHOM THESE PRESENT LETTERS SHALL COME, *GREETING*:

KNOW YE, That *Clements Rochelle* the present Sheriff of *Southampton* County, having signified his consent to continue in office another year, our Governor, with the advice of the Council of State, doth hereby commission him, the said *Clements Rochelle* to continue in the said office of Sheriff, for one year next after the expiration of his first commission, pursuant to law.

In testimony whereof, these our Letters, are sealed with the Seal of the Commonwealth, and made patent.

WITNESS, *John Floyd* Esquire, our said Governor, at Richmond, on the *tenth* day of *December* in the year of our Lord one thousand eight hundred and *thirty* and of the Commonwealth the *fifty fifth*

John Floyd

This official document certifying Clement Rochelle as sheriff was signed by Gov. John Floyd in 1830. This is significant because of the timing. Sheriff Rochelle was responsible for Nat Turner's jail stay before his trial. (Courtesy Southampton County Courthouse.)

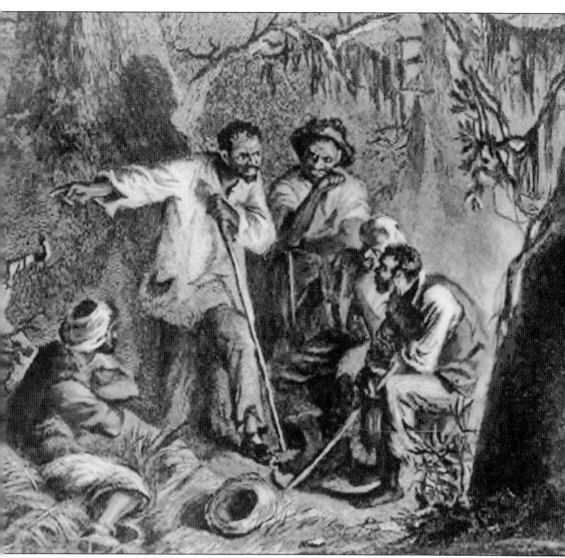

This drawing of Nat and his cohorts shows him preaching. It is said that Nat (born around 1800) had the gift of inspirational words, which is akin to the old slave saying "He had letters on his tongue." Once he was captured and hanged, some whites stated that fear of rhetoric overtook them. Some newspaper accounts argued for not allowing slaves to learn to read, write, or become preachers. (Courtesy Library of Congress.)

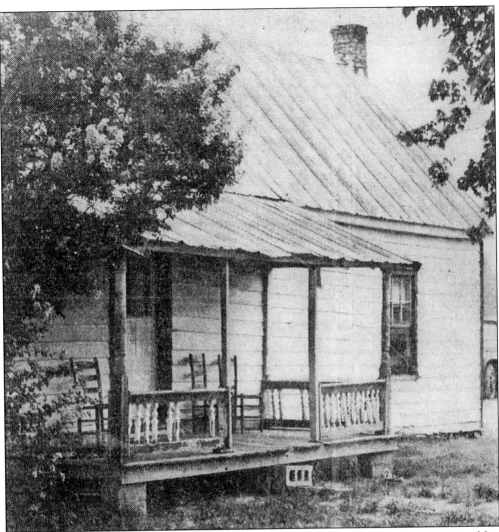

The Joseph Travis house (pictured above) was the first to be invaded by Nat Turner and his cohorts, Hark Travis, Henry Porter, Jack Reese, Samuel Francis, Nelson Williams, and Will Francis. Five people were killed, including Turner's then-owner, the young Putnam Moore. With Moore's death, Turner may have believed he was a free man. Within a couple of days, their number reportedly increased to 15 insurgents. The group continued through neighboring farms, killing nearly everyone they found—approximately 60 people. At their height, there were between 50 and 60 insurgents. Soon met by armed whites, the insurgents disbanded. Many of them were killed along with mass killings of uninvolved blacks. (Photograph by William L. Ellison, courtesy *Virginian-Pilot*, August 22, 1965.)

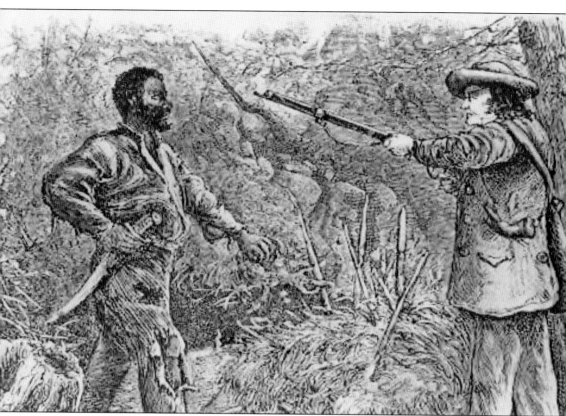

Nat Turner eluded capture for two months. In that period, Governor Floyd issued a proclamation allowing for a $500 reward to be paid for his capture. On October 30, 1831, Benjamin Phipps found him in a cave. In this etching, Nat, sword on his side, walks unrepentant toward Phipps. Phipps later got his reward. (Courtesy Library of Congress.)

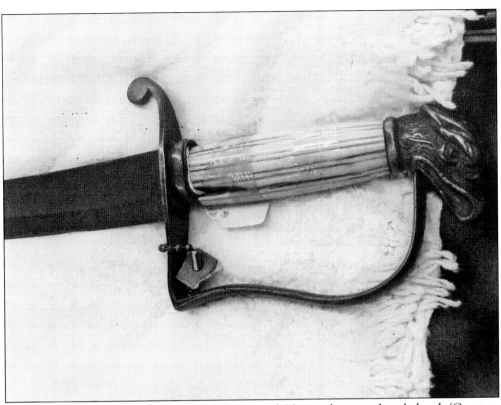

This is a detailed view of the handle of Nat's sword. Notice the carved eagle head. (Courtesy Southampton Agriculture and Forestry Museum and Heritage Village.)

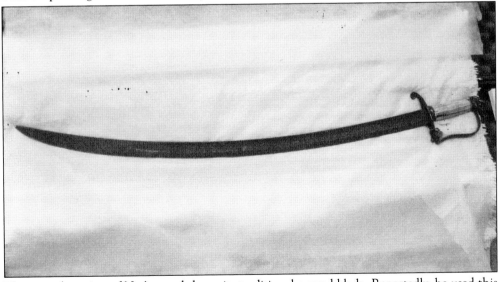

This complete view of Nat's sword shows its traditional curved blade. Reportedly, he used this sword to hit two of his victims, Sarah Newsome and Margaret Whitehead, over the head. Sarah Newsome was killed by Will Francis. Margaret Whitehead was killed by Nat—the only person he reportedly killed during the raids. (Courtesy Southampton Agriculture and Forestry Museum and Heritage Village.)

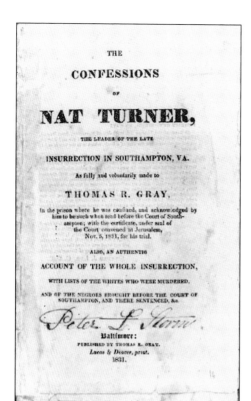

The Confessions of Nat Turner was transcribed by Thomas R. Gray, the only man who would speak directly to him. Over a period of a few days, Gray presumably wrote Nat's words and added his own commentary regarding Nat's demeanor and the fervent manner in which he took responsibility for them. He published it in Baltimore and sold approximately 50,000 copies. (Courtesy PBS.org.)

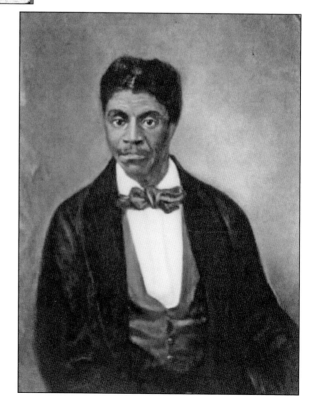

Dred Scott, born in this county in 1800, was a slave of Peter Blow. After being sold and moved several times, he sued for his right to be free since he lived in Illinois, a free state, with his owner. The famed case *Dred Scott v. Sanford* began in 1847 and ended in 1857 with the decision that Scott had no right to sue because, as a black man, he was not a citizen. Exasperated, the children of his original owner purchased Scott and his wife and freed them. Scott died six months after the court's decision. (Courtesy Library of Congress.)

THE COMMONWEALTH OF VIRGINIA,

To all to whom these Presents shall come, Greeting:

Know Ye. That our Governor, having been certified of *his* election by the Voters of the *Second* District of *Southampton* County, doth hereby commission *John Barham, (in the place of Benjamin E. Pope, who refused to qualify)* to be JUSTICE OF THE PEACE in and for the said County, who shall reside in *his* said District, and hold *his* Office for the term of Four Years, commencing on the first day of August 1852.

IN TESTIMONY WHEREOF, These our Letters are sealed with the Lesser Seal of the Commonwealth and made Patent.

WITNESS, JOSEPH JOHNSON, ESQUIRE, our said Governor, at Richmond, this *twentieth* day of *October* in the Year of our Lord one thousand eight hundred and fifty-two, and of the Commonwealth the seventy *seventh*.

Two of Southampton's most prominent men appear in this 1852 document. The Barham family was one of the first to settle in the Capron section of the county, along with Benjamin Pope. Pope refused to qualify as justice of the peace; thus, John Barham was appointed in his place. (Courtesy Southampton County Courthouse.)

William Mahone (1826–1895) was a railroad president, a decorated Civil War general, and a controversial political leader. He was founder of the Readjuster Party, which was made up of conservative Democrats, Republicans, and African Americans who sought a reduction in Virginia's prewar debt. In 1881, he was elected to the U.S. Senate. He eventually lost local support because of the political alliances he formed in his party. (Courtesy old-picture.com.)

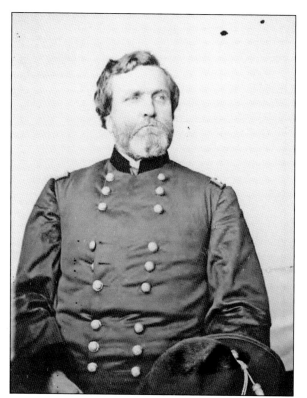

The son of John and Elizabeth Rochelle Thomas and the husband of Frances Kellogg of Troy, New York, Maj. Gen. George Henry Thomas (1816–1870) was a West Point graduate, a career soldier, and a very successful Civil War hero, but not as a Confederate. Ostracized by his family for putting his allegiance to the United States before his birth state of Virginia, this Union general's decisive victories in Tennessee and Georgia sealed the war effort in the Union's favor. After the war, he made his home in New York. (Courtesy Library of Congress.)

William James Barker, a Confederate soldier, was born on December 10, 1832, and was a direct descendant of John Barker of England, who fought in the 2nd Virginia Regiment at Valley Forge with George Washington in the Revolutionary War. William and his wife, Clementine, had seven known children. She died between 1870 and 1875. He had three known children with his second wife, Sallie. (Courtesy Frederick Barker Jr.)

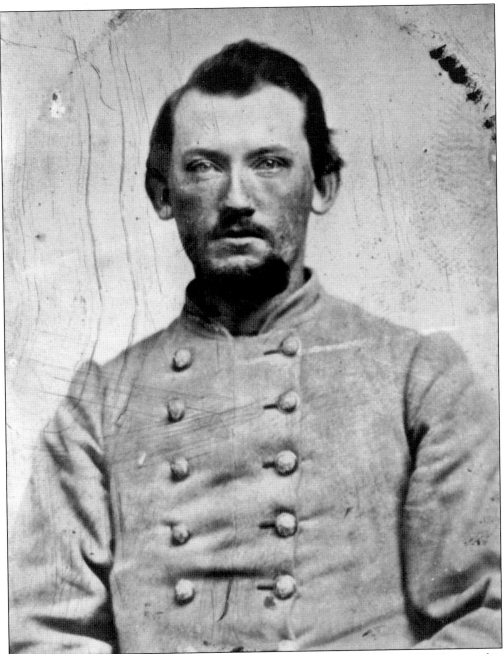

Littleton Allen Gay was the son of William E. and Laura Ann Gay. In the Civil War, he served in Company D of the 3rd Confederate Infantry Regiment. He entered as a sergeant and ended his service as a first lieutenant. After his service, he married E. Rosa Bryant, the daughter of farmers James and Elizabeth Bryant, on March 29, 1866. (Courtesy Walter Cecil Rawls Memorial Library.)

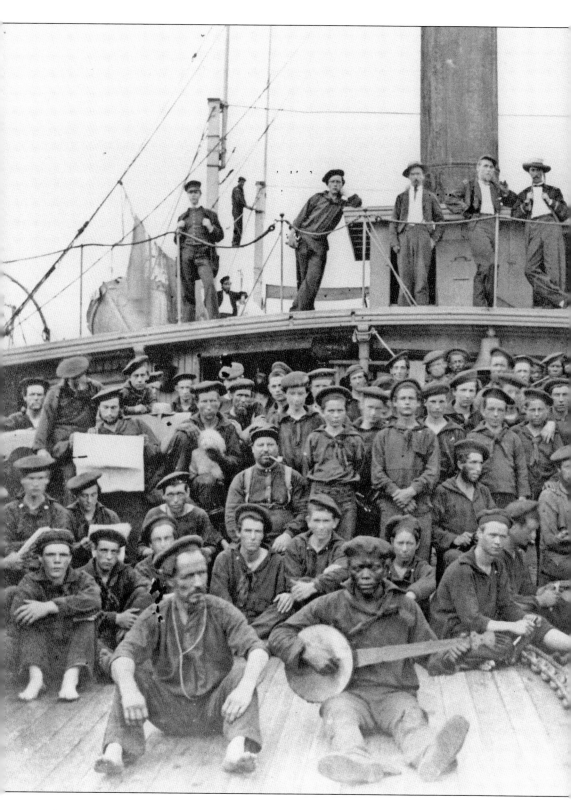

This is the naval ship USS *Hunchback* (around 1864–1865) as it was docked in the James River. In 1864, blacks were allowed to join the war. Here one can see that approximately one-fifth of the crewmen are black. (Courtesy U.S. Navy Photograph Center.)

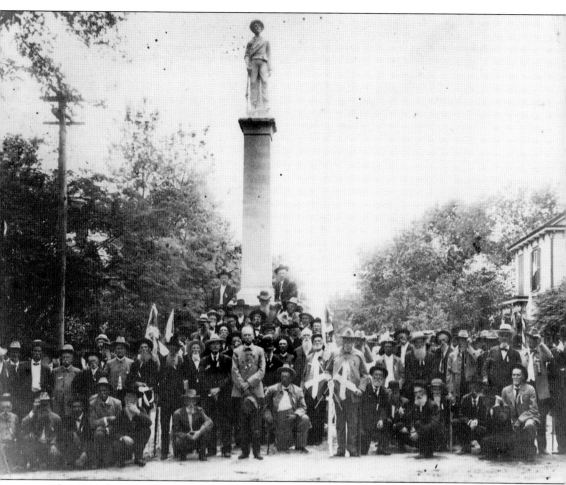

This 1911 photograph was taken at the unveiling of the monument in Franklin to commemorate Southampton's Confederate war heroes, living and deceased. The monument was later moved to the square at the county courthouse, overlooking the Nottoway River. (Courtesy Walter Cecil Rawls Memorial Library.)

Richard Henry Rawls (1845–1926) was the fourth son of Rev. Robert and Mary Ann Norfleet Rawls. As a Confederate soldier, he fought in Capt. A. J. Jones's company in the Pamunkey Heavy Artillery Division. After the war, he married Mary Kilby and had two children. After Mary's death, he married Fannie Taylor Bailey, and they had seven children. In 1908, when Ivor became incorporated as a town, Rawls was inducted as its first sergeant. This photograph was taken around 1920. (Courtesy Town of Ivor 100th Celebration.)

Southampton County had a large number of men who served in World War I. Here at their homecoming on June 25, 1919, they are posed for a commemorative photograph. (Courtesy Southampton Agriculture and Forestry Museum and Heritage Village.)

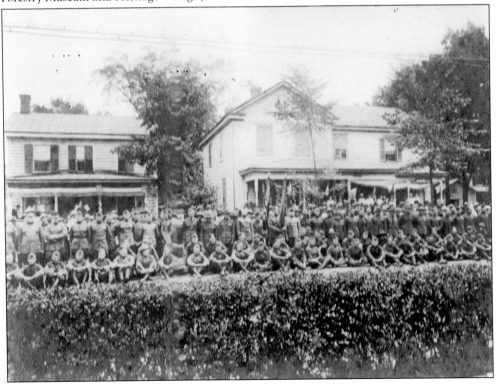

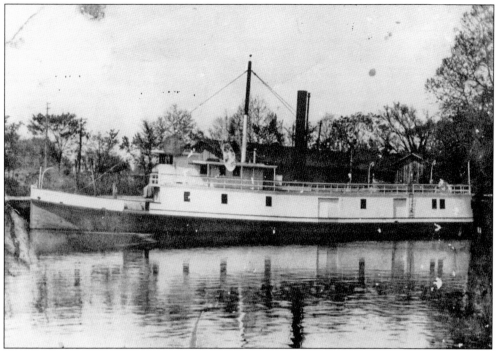

Around 1900, steamers owned by the Albemarle Steam Navigation Company began traveling back and forth on three routes to North Carolina through the waters of the Blackwater, Nottoway, Meherrin, and Chowan Rivers. Featured above around 1903 is the steamer *Hertford*. Below is a 1907 view of the revenue cutter *Pamlico* arriving in Franklin. (Both courtesy U.S. Coast Guard, National Archives.)

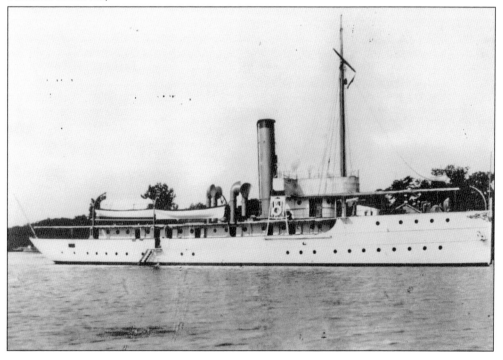

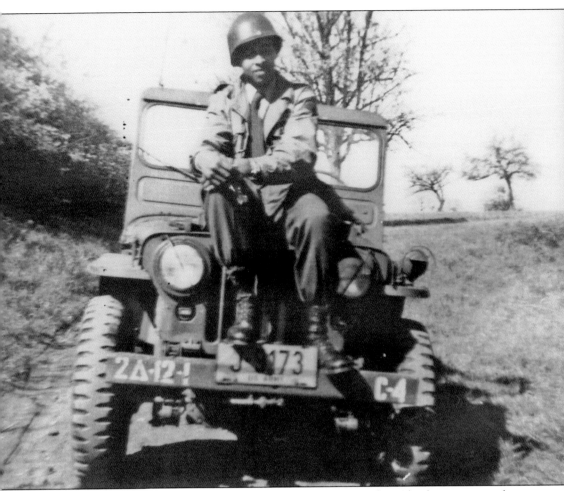

Obadiah Claud, the son of farmers Guy Franklin and Viola B. Rogers Claud, was stationed in Germany during World War II. As a member of the transportation pool, one of his duties was to ensure the smooth operation of all vehicles. (Courtesy Obadiah Claud.)

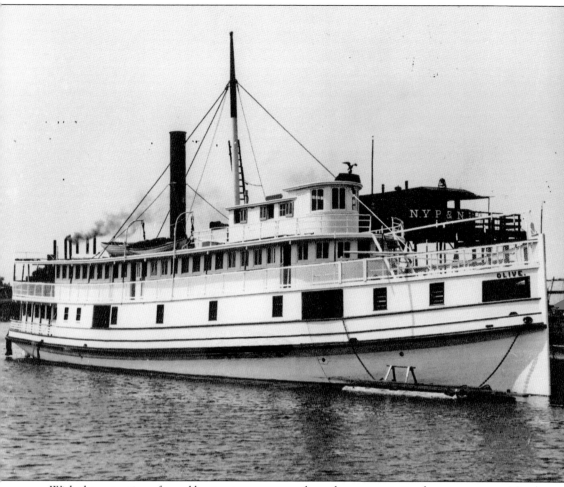

With the exception of canal boats, steamers were the only transportation between eastern North Carolina and Norfolk. The steamer *Olive* (pictured around 1911) was struck by a cyclone and sank 35 feet where the waters were only 3 miles wide. Its captain, George Withy, along with three passengers and one chambermaid, were left on the boat after the rest of the crew escaped on the lifeboat. The five of them were saved from drowning when the steamer's pilothouse and hurricane deck broke loose and floated off. They were rescued the next day by the Norfolk and Southern steamer. (Courtesy Mariners Museum, Newport News, Virginia.)

Two

SUSTENANCE

All work is valuable, because its product is necessary for putting food on the table. Represented in this chapter is the range of work and talent that drove the communities. Each of the county's seven townships operated independently of one another. That is largely because the county's landmass is more than 600 square miles and because the method of transportation was by horseback. People were required to be self-sufficient.

As economies grew, more services were offered. The overwhelming underlying factor, however, is that having one's own land was important to one's livelihood. Farming formed the basis of a family's sustenance. The most successful farmers supplemented their income with other trades and used that income to build schools on their land for their children and others close by and to pay teachers.

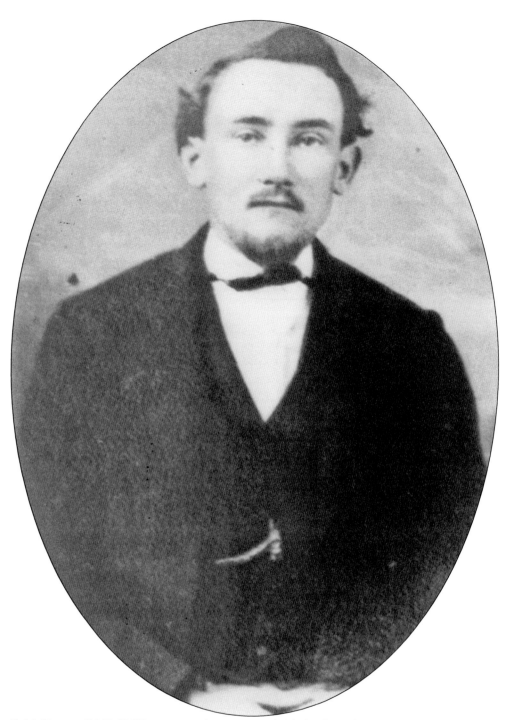

Caleb Everett (1847–1905) was an early inventor who helped revolutionize peanut farming by developing the first peanut planter, which he patented in 1892. By 1870, he was a farmer with $3,000 in real estate and personal wealth. On December 22, 1875, at the home of Amos Pope, he married Bettie R. Gillette, the daughter of Joseph and Emeline Gillette. (Courtesy Southampton Agriculture and Forestry Museum and Heritage Village.)

Benjamin Hicks (1847–1925) was a blacksmith and inventor who developed the design for the first peanut-picking machine. It was patented in 1901 and manufactured by Benthall in Suffolk. Hicks married Margaret Chappell in 1869. They had 10 surviving children. He died on the more than 100 acres he accumulated in his lifetime. (Courtesy Southampton Forestry and Agriculture Museum and Heritage Village.)

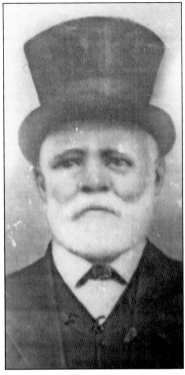

This machine design is the one patented by Benjamin Hicks and manufactured by Benthall. It usually required a seven-man crew to operate. Rather than having to pick and de-stem peanuts by hand, the machine was able to do it all. (Courtesy Southampton Forestry and Agriculture Museum and Heritage Village.)

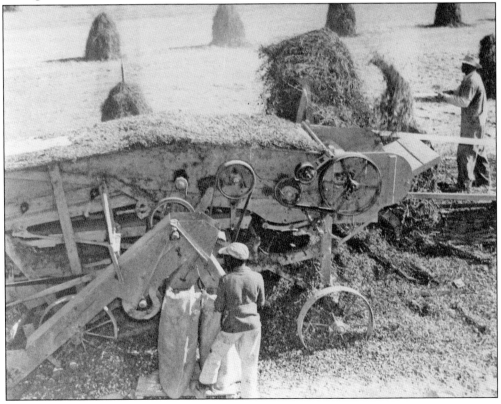

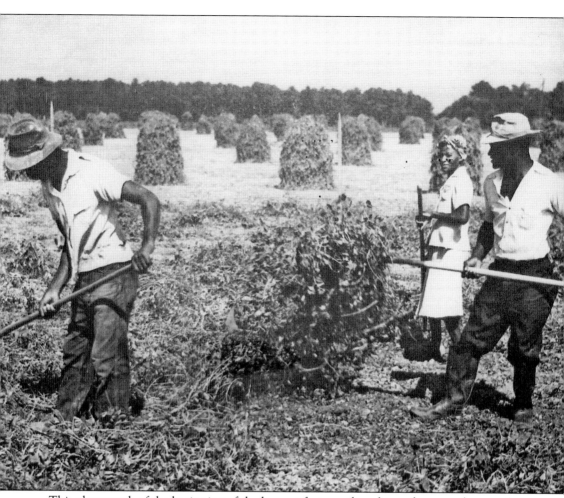

This photograph of the beginning of the harvest features the raking of peanut plants and vines into piles. (Courtesy Southampton Forestry and Agriculture Museum and Heritage Village.)

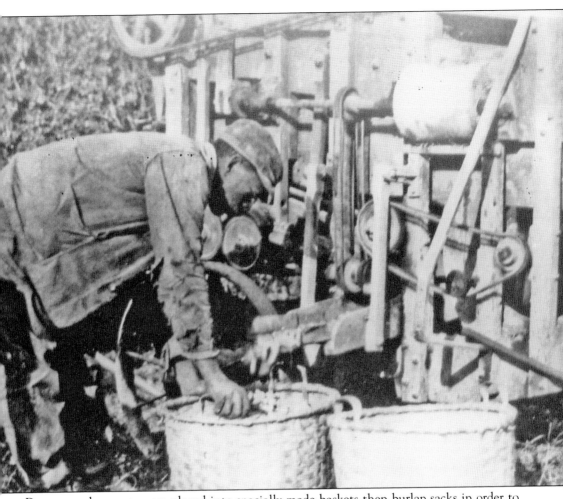

De-stemmed peanuts were placed into specially made baskets then burlap sacks in order to ready them for the market. (Courtesy Southampton Forestry and Agriculture Museum and Heritage Village.)

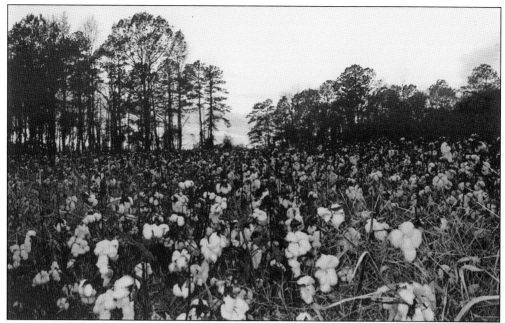

Cotton was the economic driver for the county until 1818, when the crop failed. The result was a change in spatial relations between slave owners and slaves. Slaves needed to move closer to the big house. This had implications for the ease with which the slaves who worked for the victims of the insurrection were able to quickly spread the word to neighboring farms. (Courtesy Robert Holland.)

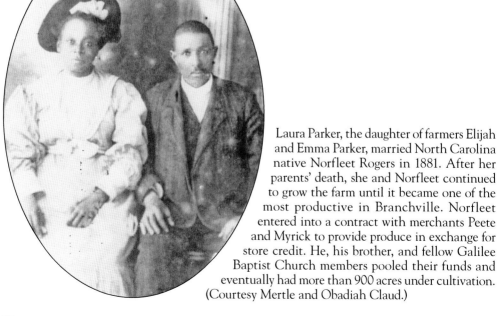

Laura Parker, the daughter of farmers Elijah and Emma Parker, married North Carolina native Norfleet Rogers in 1881. After her parents' death, she and Norfleet continued to grow the farm until it became one of the most productive in Branchville. Norfleet entered into a contract with merchants Peete and Myrick to provide produce in exchange for store credit. He, his brother, and fellow Galilee Baptist Church members pooled their funds and eventually had more than 900 acres under cultivation. (Courtesy Mertle and Obadiah Claud.)

George Wesley and Rebecca Spence Grizzard were early settlers to Drewryville. George, born in 1855 to John H. Person and Martha Grizzard, made his livelihood, like so many others, by farming. Rebecca (1851–1927) was the daughter of Eveline Spence. (Courtesy Doris Miller.)

Once married, George and Rebecca settled land themselves, raised their family, and educated and instilled high expectations in their children. George and Rebecca were instrumental in the development and progress of Persons United Methodist Church. (Courtesy Doris Miller.)

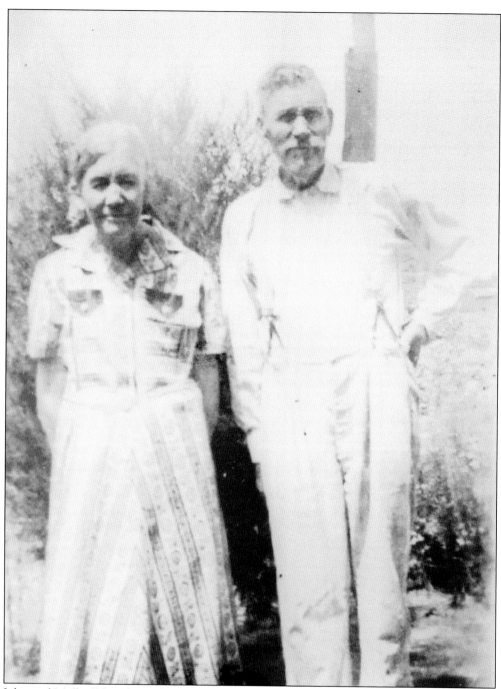

John and Mollie Edwards are further examples of the traditions of hard work through farming and of raising families that were rooted in their local church, Hebron. (Courtesy Hebron Baptist Church.)

Hack Hanson Holoman (born in 1850) survived slavery in the Ivor township and emerged with one of his brothers, James, to become a landowner and influential member of their church, Gilfield Baptist. In 1904, he executed a homestead deed to ensure his family would not be subject to losing items they needed to live daily. The stated value of his personal property equaled $231 and included his prized horse, worth $50. (Courtesy Ruth Wellons Lane.)

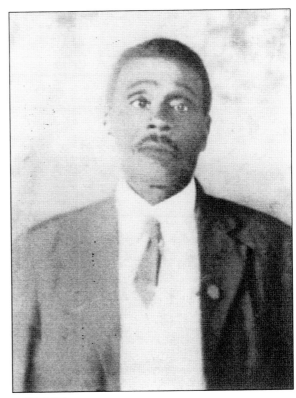

Born about 1855 to farmers Benjamin and Edith Cobb, Nancy married William A. Blythe on January 26, 1875. He was the son of William and Mariah Blythe. During the early years of the county, many couples had large families to help with all the work necessary to operate their farm. Nancy gave birth to 16 children; 10 of them lived. (Courtesy Southampton Agriculture and Forestry Museum and Heritage Village.)

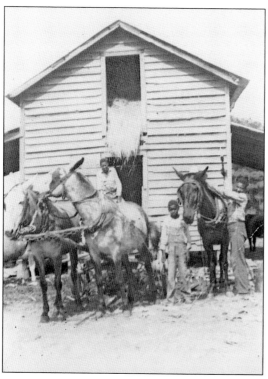

Farm work was all-consuming from sunup to sundown. Here around 1945 are (from left to right) Webster, James, and Israel Claud loading their mule-drawn carts with hay. (Courtesy Mertle and Obadiah Claud.)

The barn on the Rosewell farm was originally built by Dr. J. H. M. Sykes. It served his dairy farm, which at its height was responsible for the milking of 320 Jersey cows daily. (Photograph by Terry Miller.)

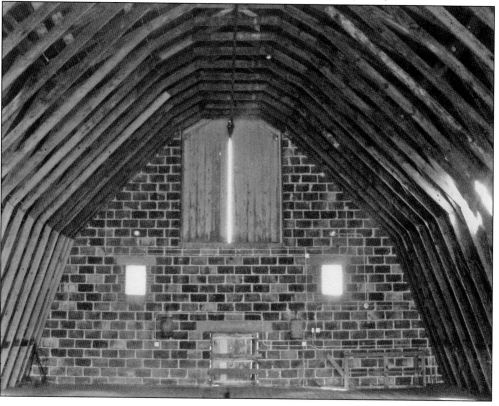

Lewis Edward Smith, born around 1874, married Bettie Copeland, the daughter of John Copeland, in 1898. He lived and worked on farmland originally bought by his father, Albert. The land is at Smith's Ferry, a key river crossing near where the Blackwater and Nottoway Rivers meet to form the Chowan. (Courtesy Leroy Smith.)

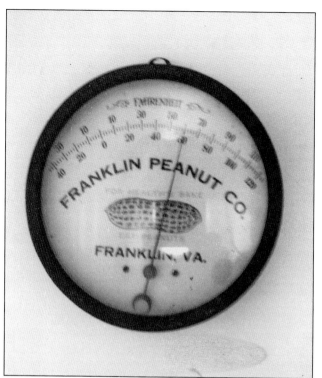

Every farmer kept a thermometer handy. This one was owned by the Smith family and hung in their old home. Made as a marketing tool for Franklin Peanut Company, the thermometer dates to around 1900. (Courtesy Leroy Smith.)

Farmers prepared for the annual hog killing by ensuring they had fattened their pigs. The largest pigs, nearly one year old, were chosen. They provided meat for entire communities for a full year. (Courtesy Richard Spier Edwards Jr.)

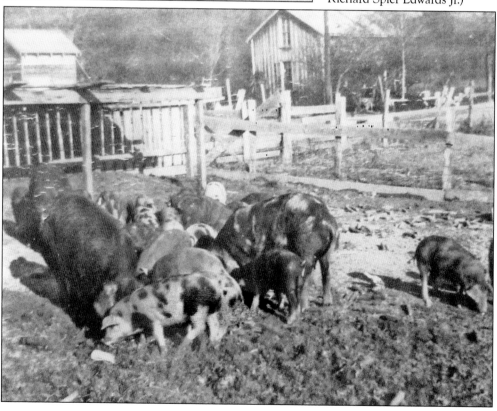

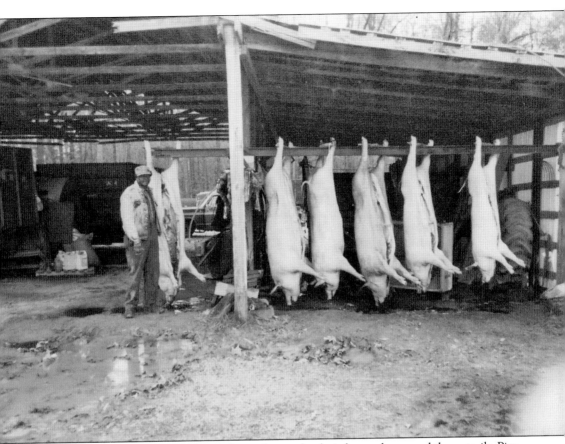

After the kill, farmers and farm laborers hung the pigs by their feet and removed the entrails. Pigs hung for a number of days, and the unusual thing is that the farm's dogs never bothered them. (Courtesy Obadiah Claud.)

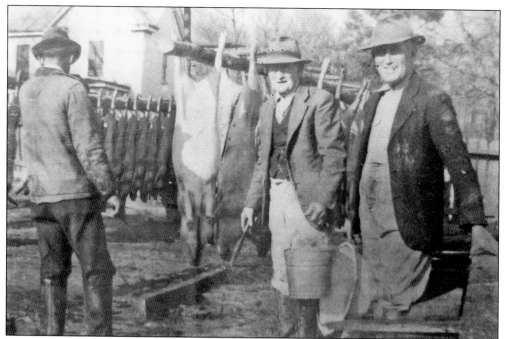

In many rural communities, cold-weather hog killing was a community bonding experience. The same is true for Southampton County. Once the dates were chosen, farmers and workers went from farm to farm to help one another until the work was done. (Courtesy of Richard Spier Edwards Jr..)

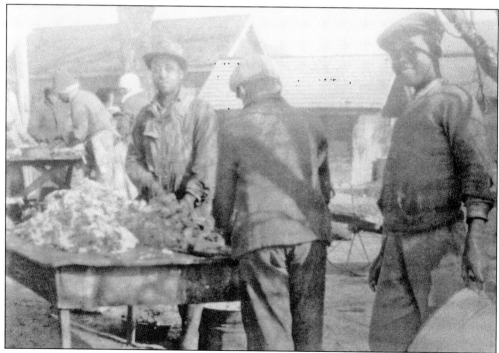

Tables to work on the pig were set up outside. Feet, ears, and entrails were cleaned and put in jars in preparation for making meals—especially sausage. (Courtesy of Richard Spier Edwards Jr.)

Frank T. Claud (1856–1948) was the son of Zilphia Claud. As a teen, he worked on the Moses and Betty Reese farm in Boykins. In 1882, he married Josephine Worrell, the daughter of Boykins farmers Nathan and Eveline Worrell. Three years after her death in 1884, he married Elizabeth Whitehead. The couple eventually bought acreage in Capron, where they farmed and raised their 11 children. Claud took pride in the unwritten rules of proper Sunday dress, even though the uniform during the week was bib overalls. (Courtesy Mertle and Obadiah Claud.)

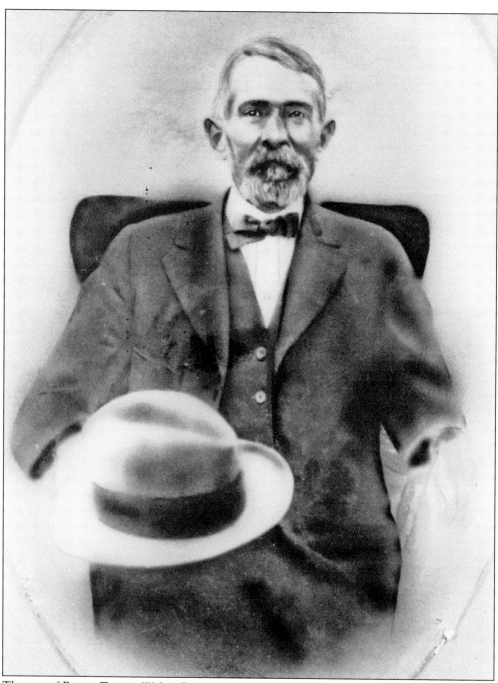

The son of Betsey Turner, Walter Boone Turner (born c. 1861), married Nina Moore (born c. 1869), the daughter of Mary Moore, on December 2, 1886. They were married in the home of William Benjamin Turner. Walter B. Turner was a farmer, entrepreneur, and one of the most successful loggers in the county. Together, the couple raised their family in the Drewryville area. (Courtesy Lynette Allston.)

Horseback was the method of transportation, and here Walter Turner "sits his horse." (Courtesy Lynette Allston.)

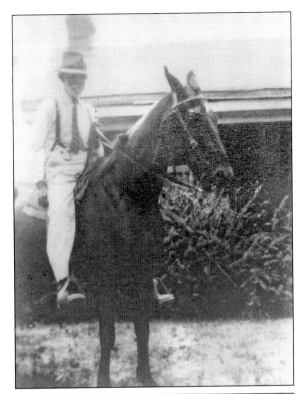

The home Walter and Nina Turner lived in was a magnificent structure situated in the midst of hundreds of acres. It was Turner's hard work in logging that provided the basis for his family's income. From left to right are Fitz, Walter Terry (seated), Laurena, Ben, Marcia, Joe Alley (seated), Woodrow, Katie, George, Walter, Nina, and Lizzie. (Courtesy Lynette Allston.)

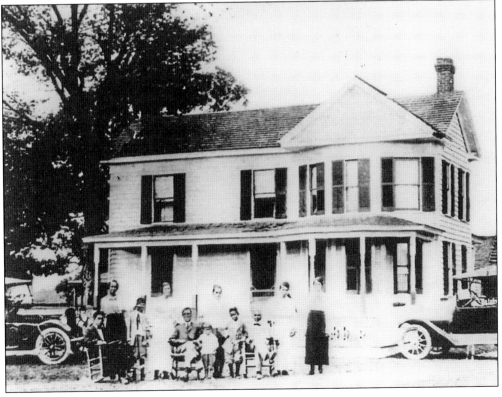

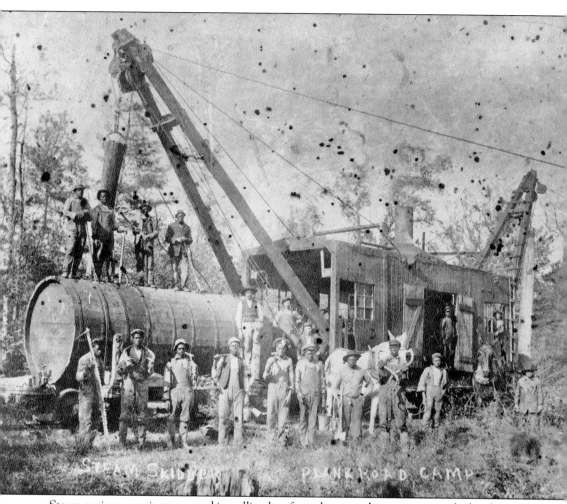

Steam engines were instrumental in pulling logs from the ground to transport to the local sawmills. This c. 1900 photograph was taken at Plank Road between the towns of Jerusalem and Petersburg. (Courtesy Southampton Agriculture and Forestry Museum and Heritage Village.)

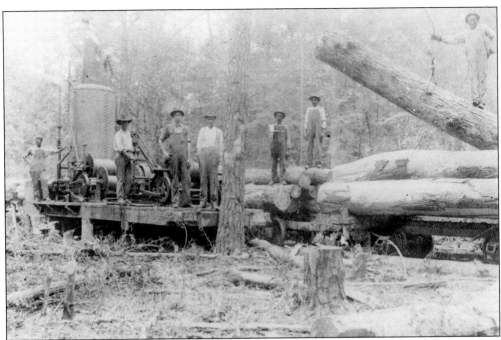

There were several logging communities such as Aarondale, Hugo, and Silverton throughout the area, where the timber was lush, strong, and thereby desirable in a number of markets. This photograph is of R. T. Lassiter and his work crew. (Courtesy Sylvia Powell.)

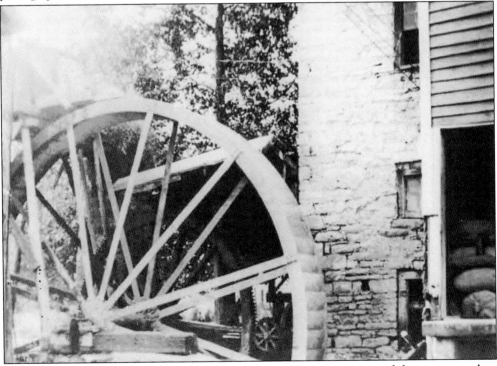

Since lumber was a major industry, sawmills were necessary to process it, and they were prevalent throughout the county. (Courtesy Library of Virginia.)

Millponds like this, which are critical to lumber and sawmilling, were dotted throughout the county. Their use was wider, however. Their banks were often meeting grounds, and the waters were baptismals for local churches. (Courtesy Robert Holland.)

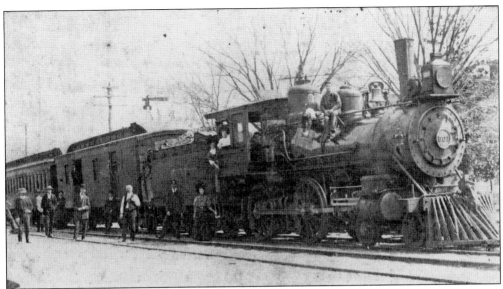

The most important development industrially was the coming of the railroad. Towns were established along rail routes, and businesses that developed could then send and receive goods. Boykins was considered a hub since it had both a north-south and an east-west rail route. (Courtesy Southampton Agriculture and Forestry Museum and Heritage Village.)

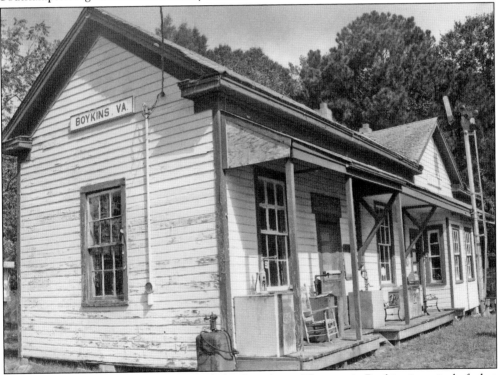

Where there was a train stop, there needed to be a depot. This one in Boykins is typical of what would have been seen throughout the townships of the county. There were designated windows or doors that served "Coloreds" and "Whites" separately and were so labeled. (Photograph by Terry Miller.)

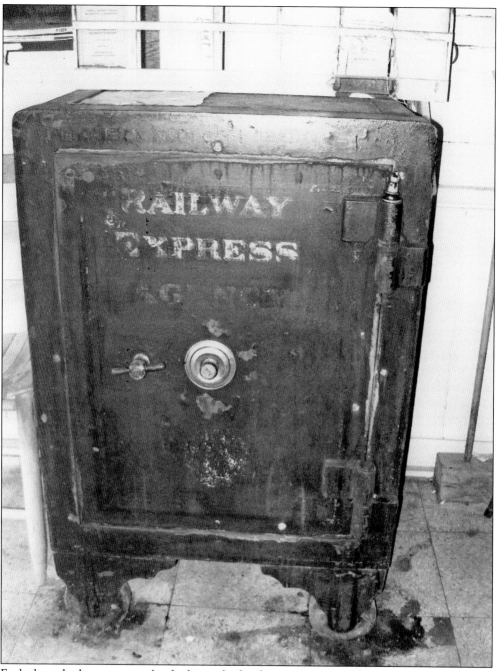

Each depot had a secure steel safe that only the depot manager could access. (Photograph by Terry Miller.)

Depots typically had three or four rooms. The control room was equipped with everything needed to communicate with train conductors and to keep proper schedules. (Photograph by Terry Miller.)

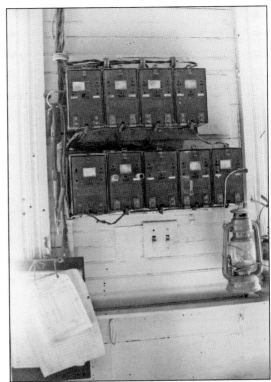

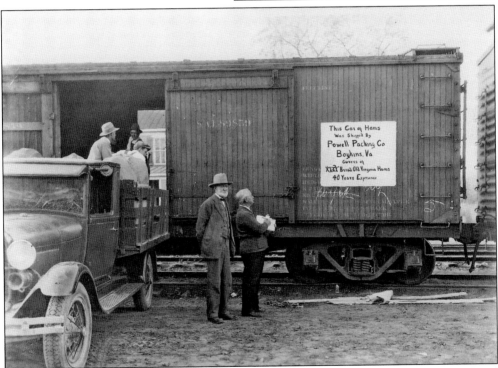

Powell Packing Company was a booming business in Boykins that relied heavily on the railroad to ship and receive its goods. (Courtesy Sylvia Powell.)

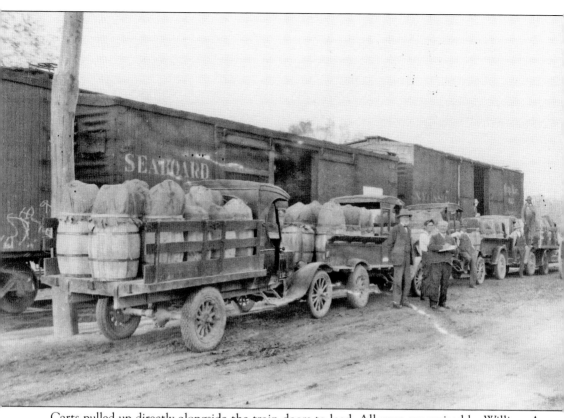

Carts pulled up directly alongside the train doors to load. All were supervised by William A. Powell himself. (Courtesy Sylvia Powell.)

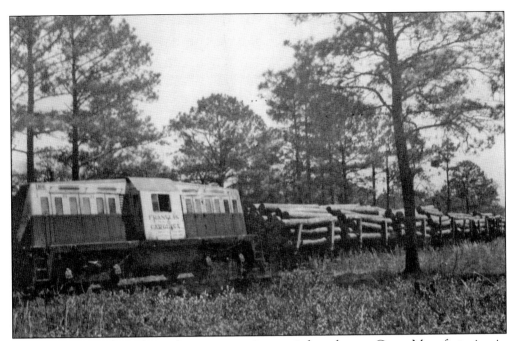

A common sight throughout the county, trains carried cut logs to Camp Manufacturing in Franklin. (Courtesy Southampton Agriculture and Forestry Museum and Heritage Village.)

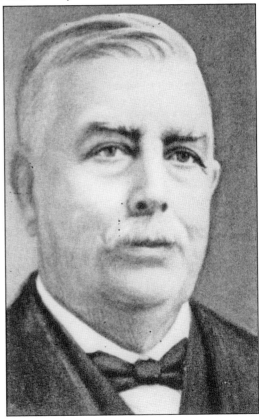

The combination of river and rail transportation in Franklin created the conditions for new industry. In 1887, Paul D. Camp, along with his brothers Walter and Robert, paid $93,000 for the sawmill owned and operated by J. and W. Neely Brothers. The new Camp Manufacturing Company gave the population an alternative to farm laboring and contributed significantly to the increase in incomes in county families. (Courtesy *Union Camp Fine Paper Division Centennial Book*, 1987.)

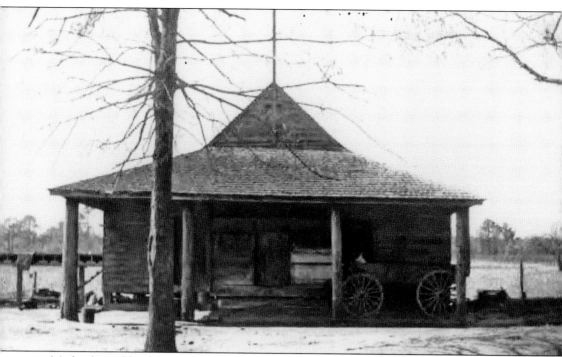

Modest barns like this one dot the landscape throughout Southampton County. They held loads of farm equipment, hay, and other goods. More prosperous planters erected two-story structures where the first level housed animals and some equipment and the upstairs held mostly hay. (Courtesy Library of Virginia.)

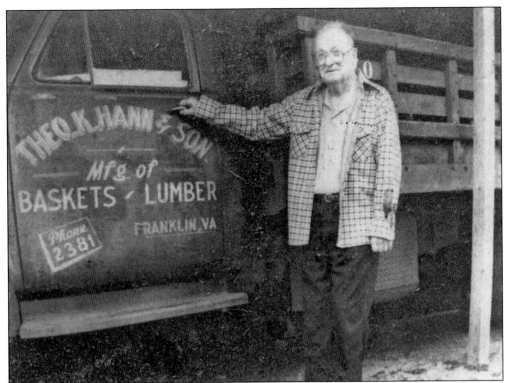

Trucking businesses like this one contributed to a thriving economy as well. R. W. Newsome, the former chief millwright of Hann Basket Factory in Franklin, poses with the company's 1953 truck. (Courtesy Southampton Agriculture and Forestry Museum and Heritage Village.)

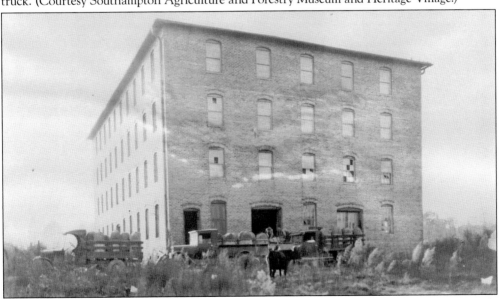

Once thought of as a skyscraper, this four-story building was originally built by the townspeople of Boykins to house their first industry, a buggy factory. Being tired of waiting for Franklin to send buggies to sale, the townspeople raised their own money and petitioned a North Carolina company to allow them to manufacture buggies in Boykins. (Courtesy Kitty Lassiter.)

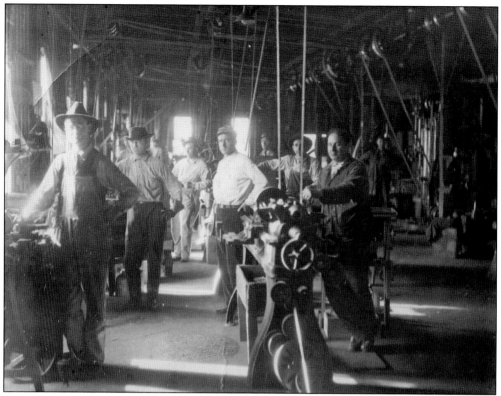

Later that same building manufactured automobiles like this one. (Above courtesy Town of Boykins; below courtesy John Wilroy.)

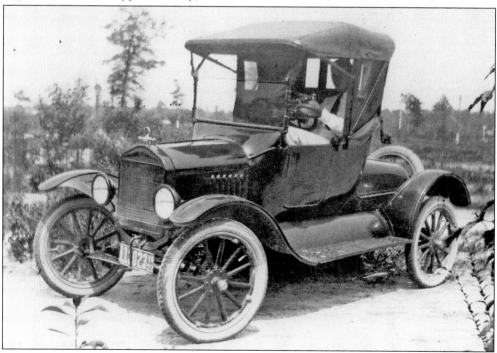

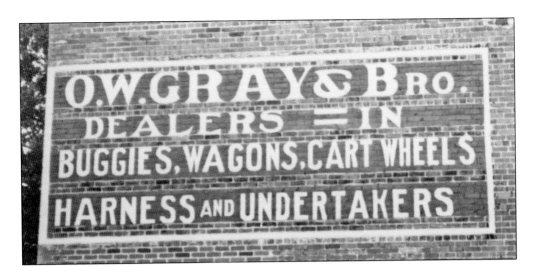

The brick building went through many incarnations in its lifetime, including being a ham-processing plant for 4X brand hams, as evidenced by the hams curing on the ceiling. (Both courtesy Kitty Lassiter.)

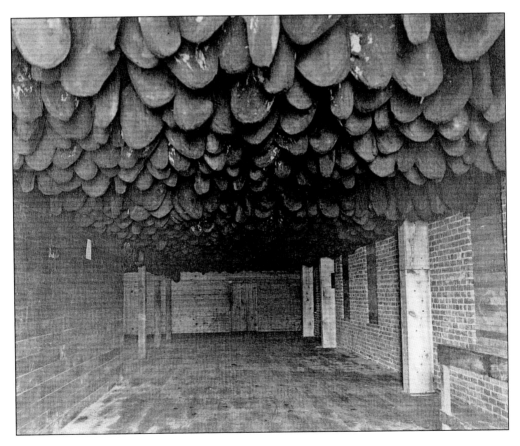

The last use of the building was as a peanut-processing warehouse. (Courtesy Kitty Lassiter.)

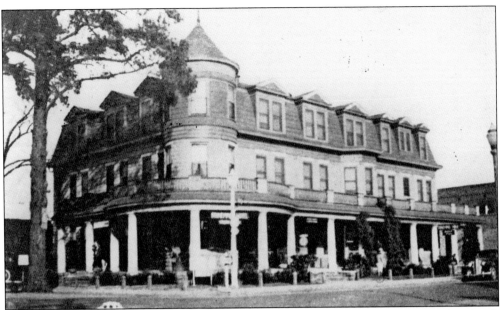

R. H. B. Cobb was the proprietor of the Stonewall Inn, a three-story, concrete, 50-room hotel with dining facilities. The hotel was located on the corner of Main and Fourth Streets in Franklin. (Courtesy John Wilroy.)

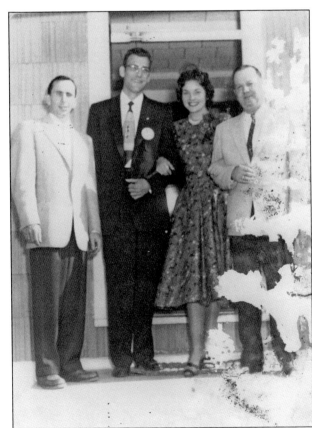

County native John Wilroy (left) stood with his two business partners and the then Miss America, Lee Merriwether, during a publicity opportunity for the partners' Philco Refrigerators store. They owned the store in North Carolina until a flood forced them to close. (Courtesy John Wilroy.)

Every town needed a doctor, and for Boykins, that was James Moncure Bland, who moved there at the urging of fellow classmate and friend Dr. James A. Grizzard of Drewryville. Dr. Bland was the son of James and Anna Irby Bland. Two years after the 1919 death of Dr. Bland's first wife, Rosa Wilroy, from malaria, he married Grace C. Knight. She was the daughter of Alexander and Catherine Knight. So influential did Dr. Bland become that he was voted the first president of Ruritan International. (Courtesy Kitty Lassiter.)

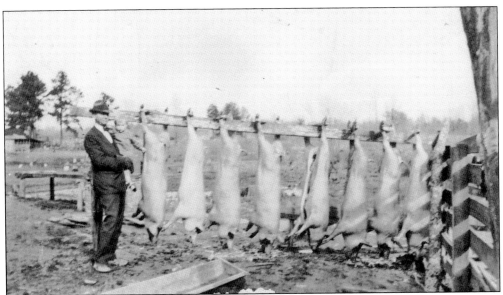

Dr. Bland was not only a doctor, but like almost everyone, he also farmed. Here he is during hog-killing season showing his daughter Kitty (in his arms) the ropes. (Courtesy Kitty Lassiter.)

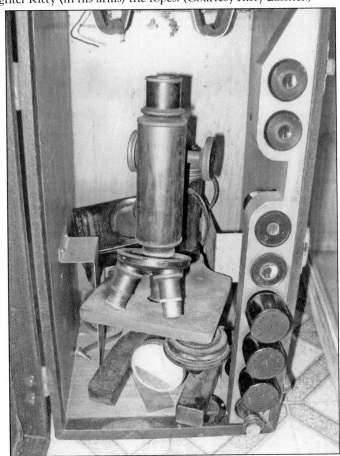

No doctor could operate without a powerful microscope. This and other tools helped doctors like James Bland make proper diagnoses. (Courtesy Southampton Agriculture and Forestry Museum and Heritage Village.)

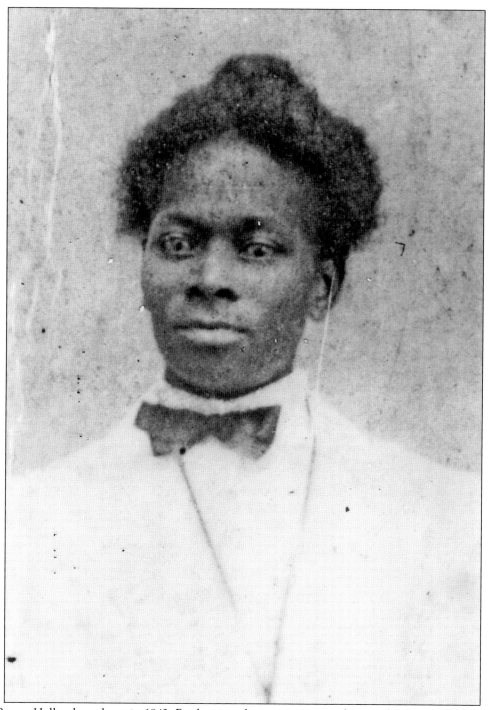

Renny Holland was born in 1842. By the time she was a preteen, she was the slave of William N. Outland in Isle of Wight County. After the Civil War, she married Charles Holland, made her home in Zuni, and worked as a midwife. After her husband's death, she moved with one of her sons, Willis, to Franklin, where she worked as a nurse in private homes and for the Hayden School. (Courtesy Terrie Smith.)

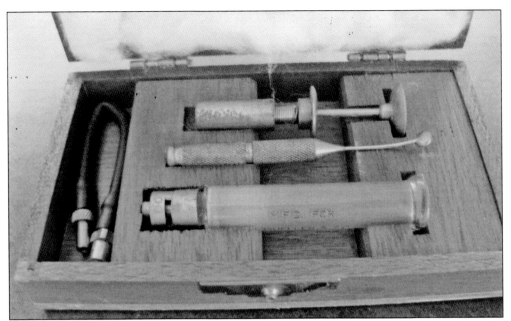

It was well thought throughout the community that "colored" people (both Native and African American) did the best doctoring, even though they were never formally trained. However, tools of various kinds came available to white country doctors and were later used by minority doctors to administer medicines. (Courtesy Southampton Agriculture and Forestry Museum and Heritage Village.)

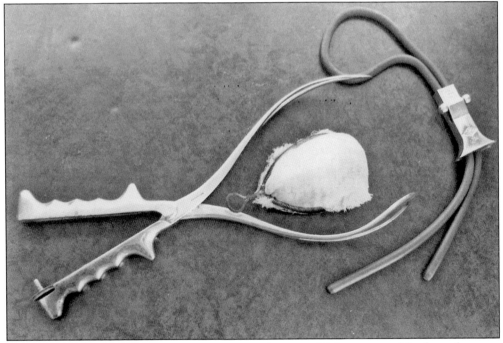

Other examples of medical instruments are stirrups, which were used both on humans and animals in deliveries, and the oxygen mask. (Courtesy Southampton Agriculture and Forestry Museum and Heritage Village.)

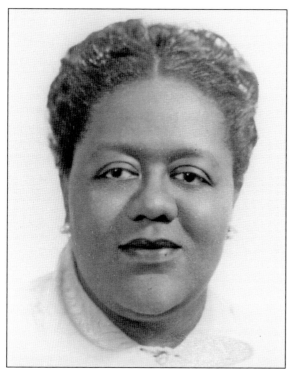

Dr. Ernell Annie Harris Holland (1917–1985) was the daughter and business partner of Dr. Frank Harris and his wife, Ethel, who was a teacher. The keeper of many medical secrets in Franklin's African American community, Dr. Ernell was known for allowing people to come to her home office at all hours for treatment. Her specialty was being able to diagnose problems simply by listening to her patients and applying her medical knowledge. (Courtesy Robert Holland.)

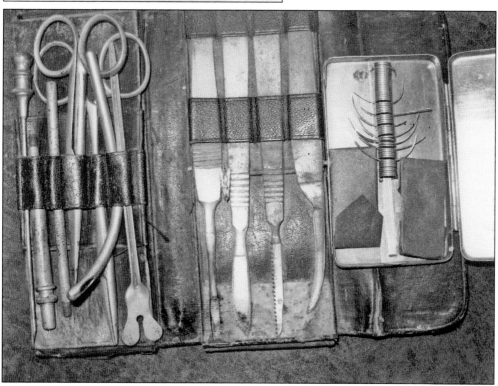

These instruments were used by medical doctors and dentists alike. Notice the sharp metal sutures. (Courtesy Southampton Agriculture and Forestry Museum and Heritage Village.)

Roswell Langston Holland (1919–1967) was a World War II veteran and the husband of Dr. Ernell Harris Holland. A native of Nansemond County, he moved to Franklin after he married in 1947 and made his business life there. Known as "Rosland" by his friends, he owned and operated a bus line and two gas stations. (Courtesy Robert Holland.)

Rhetta Hart (born 1901), the daughter of John D. and Mary L. Hart, was a socialite and 1920s flapper who was described as being both stylish and coquettish. (Courtesy Kitty Lassiter.)

She was married late in life to Roy Stewart and became the town of Boykins' postmistress in 1945. After the couple married, they moved into a house built by J. H. Pruden, the conductor on the Tar River Branch rail. (Courtesy Kitty Lassiter.)

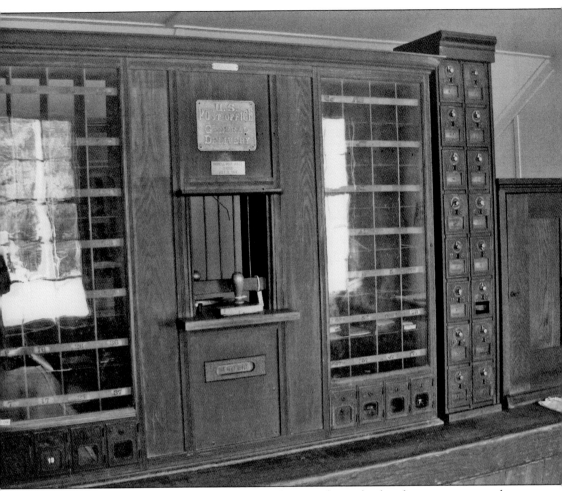

Post offices were not always stationary structures. They were located in hotels or grocery stores that were frequent victims of fire. Once post offices were established in proper locations, equipment could be purchased for the efficient giving and receiving of mail. This one was in Courtland in the early 1900s. (Courtesy Southampton Agriculture and Forestry Museum and Heritage Village.)

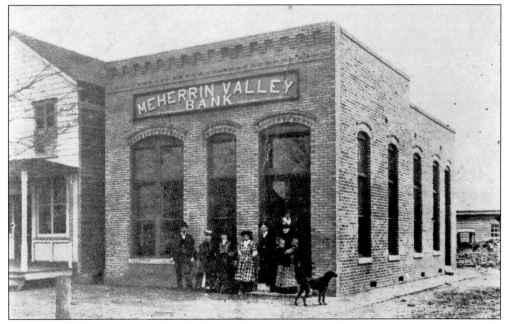

Once industry began growing, banks became important gauges of a town's capacity to grow. The Meherrin Bank was the first brick building not only in Boykins but in the entire county. (Courtesy Southampton Agriculture and Forestry Museum and Heritage Village.)

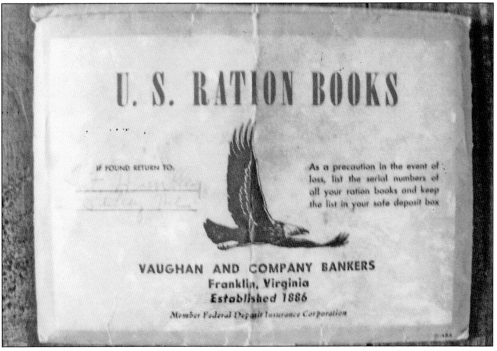

During World War II, it became necessary for people to receive rations. Vaughan and Company Bankers in Franklin, founded by Cecil C. Vaughan in the late 1880s, was key to helping people get the supplies they needed through the ration voucher program. (Courtesy Southampton Agriculture and Forestry Museum and Heritage Village.)

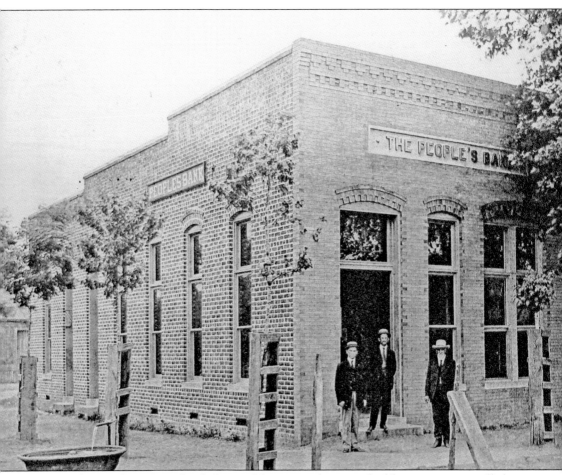

The People's Bank in Courtland, featured here, was distinguished by its artesian well that ran all day (see bottom left). (Courtesy Southampton Agriculture and Forestry Museum and Heritage Village.)

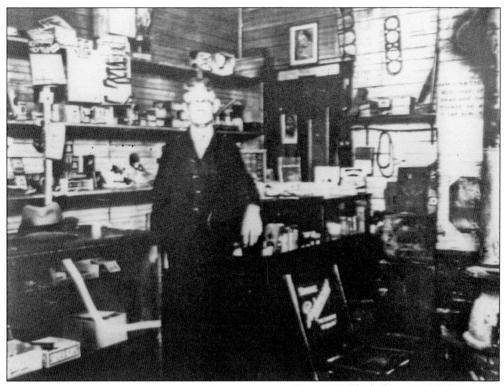

James W. Clark (born in 1876) is representative of the many merchants who owned and operated general stores. These establishments had everything a household would need, and it was if not in stock, it could be ordered. Clark owned not only a general store but also a gas station next to Rawls Grocery in the heart of Ivor. (Courtesy Town of Ivor 100th Celebration.)

Born in October 1872 to Richard Henry and Mary Kilby Rawls, Willie Calvin Rawls's first significant paying job was as a store clerk in Ivor, where he earned $5 per month. In 1900, he rented a store and went into business for himself as Rawls Grocery. He married Ruth Batten Cobb in 1916, and in addition to his grocery business, he bought, operated, and later sold several farms. In his career, he also served as postmaster, undertaker, and pharmacist. He is pictured in 1901. (Courtesy Town of Ivor 100th Celebration.)

This steel cash register, owned by J. T. Barham's store in Capron, is one that customers would see and give their money to when they came to shop. The cash register has four solid-wood drawers that were for each of the four employees to use during their shift. This way, receipts were easier to account for. (Photograph by Terry Miller.)

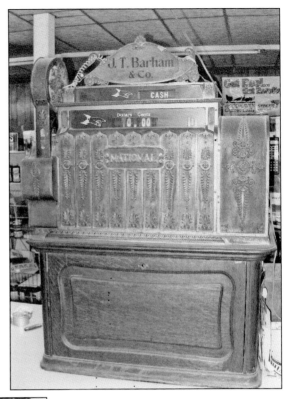

Indianna Mabry Bunn Doles was born in 1890 to John and Ann Maria Holland. She first married Conyers Bunn, and after his death, she married Frank Doles in 1930. As first a farmer's and then a laborer's wife, she needed to frequent the local general store to purchase household items that were not manufactured on her family's land. (Courtesy Beatrice Magette.)

One of the best known merchants in the county was Walter Wallace White Sr. (born c. 1863). Based in Boykins after moving from North Carolina, White's store had an upstairs that also served as a rooming house–hotel. (Courtesy Southampton Agriculture and Forestry Museum and Heritage Village.)

In 1891, in a ceremony presided over by both Rev. H. C. Smith and Rev. Thomas Wray, he married Allie Moss, daughter of Joseph and Betty Moss. (Courtesy Southampton Agriculture and Forestry Museum and Heritage Village.)

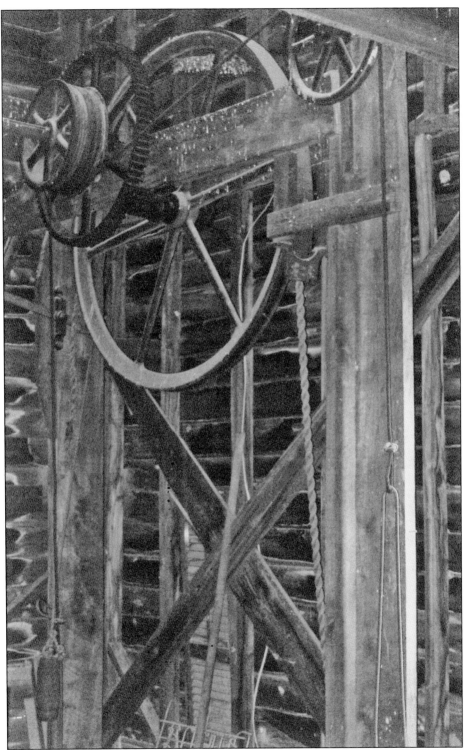

General stores with more than one story needed an elevator or lift system to haul large items upstairs to be stored. This pulley system was used by J. T. Barham. (Courtesy Ira Pete Barham.)

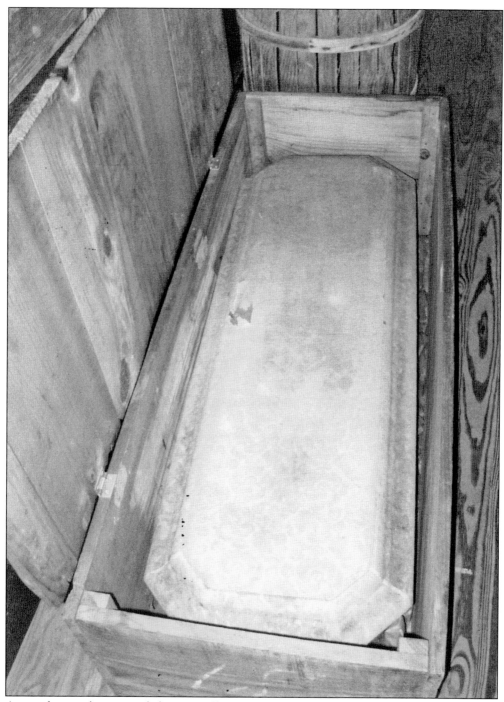

As noted, general stores needed to carry all types of merchandise. One such item was a coffin. This children's coffin, as well as those for adults, were always in stock, because customers never knew when one would be needed. The cost for an adult coffin was $30 cash-and-carry or $35 if paying over time. (Courtesy Southampton Agriculture and Forestry Museum and Heritage Village.)

Julia Holoman Wellons (born 1889) was the seventh child of Hack and Mariah Whitley Holoman and the wife of Saint Paul Wellons, a painter and professional barber. Like so many women, she was a housekeeper for well-to-do families while at the same time raising her own 10 children and educating them through the 10th grade. Two of her children died as babies. Wellons worked for both Dr. E. M. Babb and F. T. Joyner, the principal of the high school in Ivor. (Courtesy Ruth Wellons Lane.)

Walter Wallace White Jr. (born 1895) entered the merchant business with his father. By 1920, "W. W. W. Sr." had died, and his son carried on in the entrepreneurial spirit of his father. He was an electrician, and using a windmill, he generated electricity for local homes in Boykins. In April 1920, he married Katherine Capps Wilroy, and they became leaders in every sense of the word in their community. He was also a lover and breeder of pedigree dogs, his favorites being English and Irish setters. (Courtesy John Wilroy.)

No longer wanting to work on the farm, John Bowers (1875–1929), the son of farm laborer Henry and seamstress Georgianna Bowers, moved to New York, where he took a job as a porter on the railroad. He married Vermont native Marion M. Day in 1903, and over time, they had 13 children. The family moved back to Southampton, where Bowers eventually purchased a 112-acre farm from his brother, Thomas. Having lived in the Northeast throughout his adult life, he did not learn until trying that a mule was better than a racehorse when it came to plowing his fields. (Courtesy Wanda Wise.)

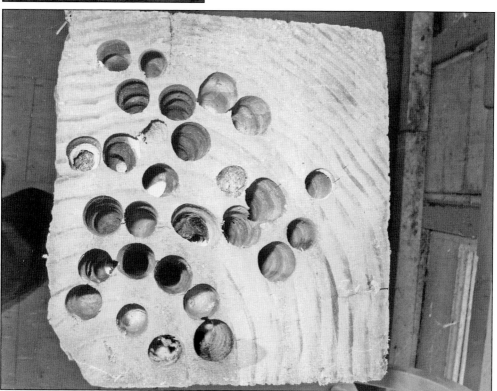

Everything and everyone works in Southampton, even wood bees. This piece of wood, more than 100 years old, has the remains of honeycombs and intricate work of wood bees that enter on one end, bore themselves in perfectly formed round holes, and come out on the opposite end. (Courtesy Ira "Pete" Barham.)

Three

GET AN EDUCATION

One-room schoolhouses were abundant throughout Southampton County because large planters erected them on their grounds to educate their children and those who worked on their farms. It was not until much later that schools were consolidated into one grade school and one high school for whites and corresponding ones for blacks. There was always a difference in the quality of building materials for white children as opposed to Native and African American children—bricks or boards, as one native would term it. Nevertheless, nearly everyone understood the merits of education. One important figure in African American education was Della Irving Hayden. Much has been written of her dedication to the craft of teaching minority children. Highlighted here are her early years, before her brief marriage to Lindsey Hayden (he died very shortly after their marriage, and she never remarried), to get a fuller understanding of her passion for teaching. Another pioneer was Frances White. Determined to be a missionary for the sole purpose of teaching the downtrodden, her entire life was dedicated to education.

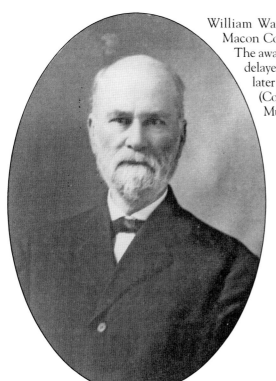

William Walter White was a graduate of Randolph Macon College and a teacher in a one-room school. The awarding of his 1861 master of arts diploma was delayed because of the start of the Civil War. He later became the county's school superintendent. (Courtesy Southampton Agriculture and Forestry Museum and Heritage Village.)

A lover of all things cultural, the educated Fannie Drewry Beaton (born c. 1856) was a piano teacher in the town of Boykins and the wife of merchant George N. Beaton (born c. 1864). She was the daughter of James and Martha Drewry; he was the son of George and Virginia Jones Beaton. (Courtesy Southampton Agriculture and Forestry Museum and Heritage Village.)

Frances White, the daughter of W. W. White Sr., always exhibited an abiding concern for the less fortunate. She converted that desire into missionary work. She was encouraged by Coretta J. Mason, the wife of Boykins High School principal John Y. Mason and an accomplished evangelist and youth missionary herself. Frances enrolled in Chowan College, eventually earning her doctorate in English. She volunteered locally and in the mountains of West Virginia to better the plight of poor families. (Both courtesy John Wilroy.)

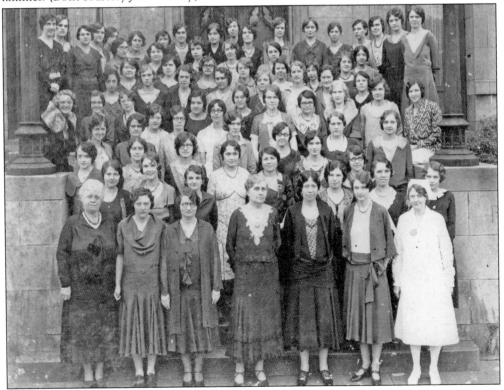

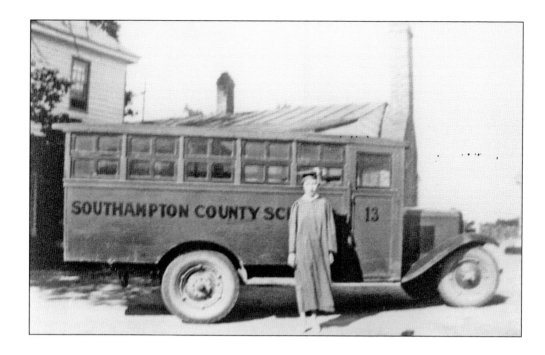

The town of Ivor had school buses for its white children, while community farmers raised the money to transport black children to and from school. Here Jenny Britt poses around 1930 at her bus near the large, two-story brick Ivor High School. (Both courtesy Town of Ivor 100th Celebration.)

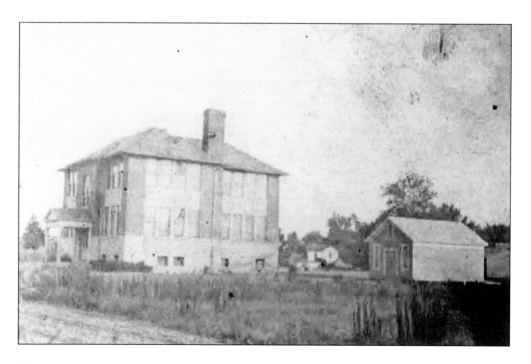

Partnerships developed among administrators who wanted to see progress for eager minority children. Dr. James Bryant, a Confederate cavalry veteran, was the school superintendent in the 1870s when he met Della Irving (born in 1851 in North Carolina), the daughter of former slave Charlotte Darden. After hearing her desire to get an education, he wrote her a recommendation to be admitted into Hampton Institute. (Courtesy School Board of Franklin, Virginia.)

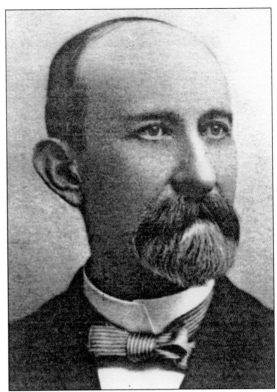

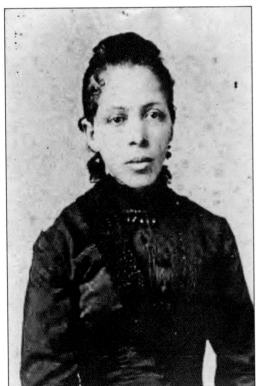

Della Irving arrived at Hampton with less than 40¢. After talking with Gen. Samuel Chapman Armstrong, Hampton's president, she worked on campus and was eventually able to enroll in 1872. (Courtesy Virginia State University.)

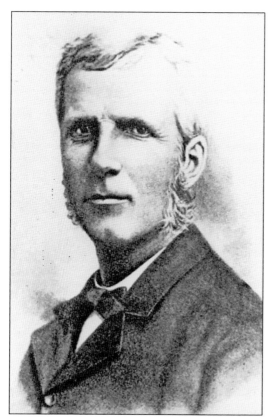

Della so impressed Gen. Samuel Armstrong that he mentored her throughout her stay at Hampton and beyond. While at Hampton, he ensured she was paid for looming and teaching her instructors and fellow students how to swim. To help finance her education, she took a leave and taught children in a one-room school on Indiantown Road. By night, she taught adults. When she returned to Hampton, she earned the distinction of being one of her graduating class speakers in 1877. She won the $20 first prize. She taught 12 years in the county, spent 13 years as principal of Virginia Normal and Collegiate Institute, and spent 21 years at the school she founded in 1904, Franklin Normal and Industrial Institute. She eventually raised enough money to have a school building and girls' dormitory constructed (shown here). (Left courtesy historycooperative.org; below courtesy Robert Holland.)

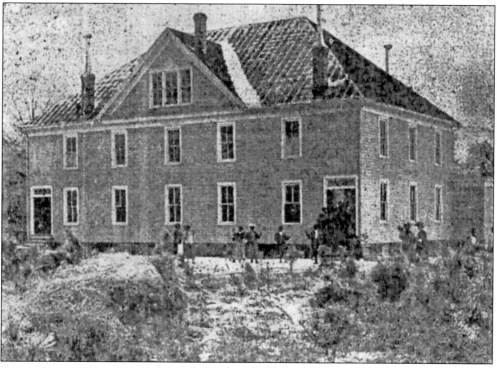

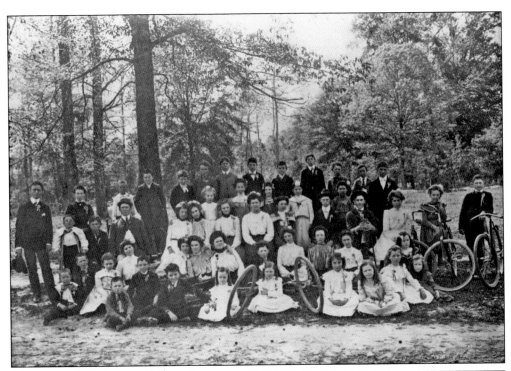

This is a *c.* 1910 photograph featuring the graduates of the Boykins School. The luxury item of the day was a bicycle, and there were several lucky children in the bunch. (Courtesy Kitty Lassiter.)

Monthly Report.

Report for Gracie Knight;
for month ending February 27, 19 03.

Algebra	9.4	Physical Geography	
Arithmetic	9.5	Physiology	
Botany		Reading	96
Civil Government		Rhetoric	
Composition	9.8	Spelling	100
Geography		Literature	96
Geometry		Latin	95
Grammar		General Average	75
History	9.1	No. Days Present	19
Orthography		No. Days Absent	0
Penmanship	9.7	No. Times Tardy	13
Philosophy		Deportment	100

Explanation.—100 signifies Very Good; 85, Good; 75, Medium; 50, Poor; 25, Unsatisfactory.

To Parents and Guardians.

Parents and Guardians will confer a lasting benefit upon the pupil if they will co-operate with the teacher in securing regular attendance. Systematic and constant effort will be made to interest pupils and to stimulate them to a thorough and diligent exercise of their intellectual and moral faculties. Your co-operation will greatly aid in making the work successful.

R. W. Grizzard,
Mrs. S. L. Beaton. , Teacher.S
March 9, 1903

J. R. Holcomb & Co., Publishers, Cleveland, O.

Report cards were given regularly so that children could show their parents their progress. This 1903 report shows that the curriculum was quite different from what is currently taught in schools. (Courtesy Kitty Lassiter.)

'Mammy's Lil' Wild Rose'

A Comedy-Drama of The Sunny South

Will Be Presented By

THE SENIOR CLASS
OF IVOR HIGH SCHOOL

FRIDAY, APRIL 1st.

8:00 O'CLOCK P. M.

High School Auditorium
Ivor, Virginia

Admission: Adults 25c - Children 15c

SPECIAL ATTRACTION
Waverly High School 35 Piece Band

All types of extracurricular activity occurred in school, and one of the most popular was putting on theatrical performances. Here Ivor students participate in a fund-raising play. (Courtesy Town of Ivor 100th Celebration.)

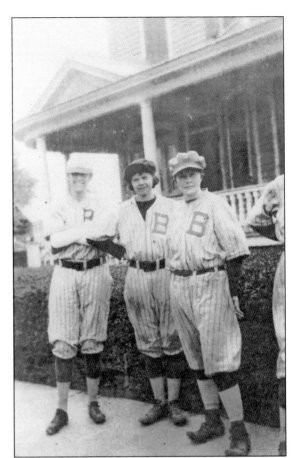

Here members of the Boykins High softball team celebrate one of their many victories. This bricked Boykins High school photograph dates from the early 1900s and shows the care with which it was built for its students. It also is a testament to the wealth of the town during that period. (Right courtesy of John Wilroy; below courtesy Town of Boykins Office of the Mayor.)

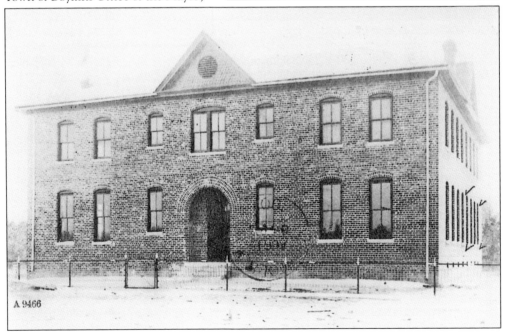

A 9466

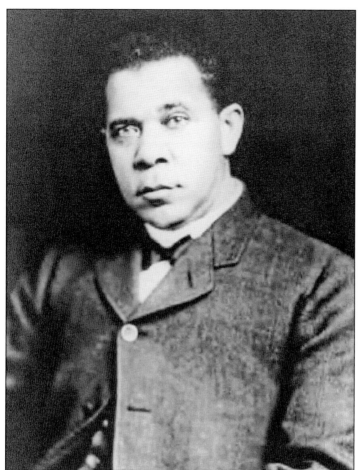

Booker T. Washington graduated from Hampton Institute one year before Della Irving, and they stayed in touch as his career grew nationally. Della often invited and Washington accepted invitations to speak in Franklin on behalf of increasing the number of black teachers and teaching excellence. (Courtesy Terry Miller, private collection.)

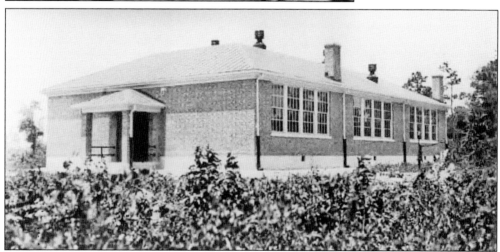

Newsoms Colored School was one of the best built schools in the area for black children. Though schools were usually made of wood planks, this structure was sturdier and provided much-needed education for many children in one of the oldest parts of the county, Newsoms. (Courtesy Library of Virginia.)

Four

JUST A LITTLE PEACE

Everyone contributes in his or her own way. Perhaps the most enduring contribution was related to churches. It has been written that religious life was not as important in the county because residents were more concerned with secular life: brandy making and horse racing; however, that may not be true. Even if residents' interests were secular, there was always a desire for a spiritual life. Churches sprang up in distant areas throughout the county because people wanted to get together to exchange news about one another. Itinerate preachers circuited the back roads on horse and buggy. As early as 1786, people were organizing churches. The first, from which five other congregations grew, was eventually named Hebron Baptist.

Conyers Bunn, the second known child of John and Ann Bunn, was the first of his immediate family born in Virginia. Between 1878 and 1882, his family left their North Carolina home and moved to Newsoms. Conyers married Indianna Mabry, and in his old age, he lived with one of his sons in Franklin. Using his cane, he engaged in a regular game with his grandchildren by sitting at the bottom of the home stairway and pretending to trip them when they came running. They returned the favor by pretending to fall, and all would end with laughter. (Courtesy Beatrice Magette.)

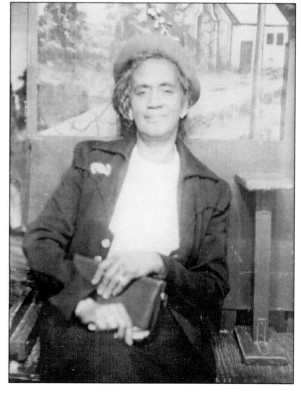

Adnie Jane Johnson Lane (1891–1966) was born to Beverly and Jane Davis Johnson in the Scrutchelow community near Tucker Swamp. Their fourth living child, she was the namesake of her paternal grandmother, Adney Crumpler. Adnie Johnson's mother died some time between 1901 and 1906. With small children to raise, her father remarried in 1906 to Malvina Woodward. Adnie became the wife of Charles Lane in 1912 and moved to land that he had purchased for $150. Their land purchases grew to more than 50 acres by 1917. (Courtesy Ruth Wellons Lane.)

This natural beaver top hat was made in Paris, France, and imported to be worn on the head of one of Southampton County's more tony gentlemen, M. G. McClenny. (Courtesy Southampton Agriculture and Forestry Museum and Heritage Village.)

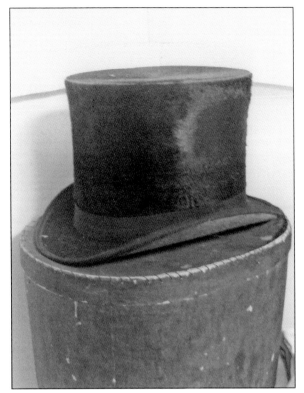

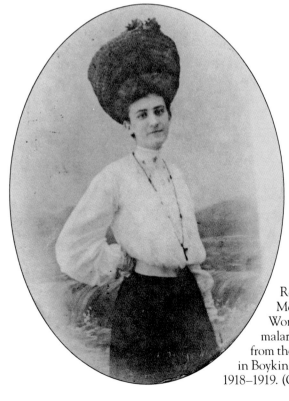

Rosa Wilroy Bland was the wife of Dr. John Moncure Bland and president of the local Women's Club until her untimely death from malaria in 1919. There was a mosquito infestation from the stagnant waters of the local Tarrara Creek in Boykins, and many lost their lives in the period of 1918–1919. (Courtesy John Wilroy.)

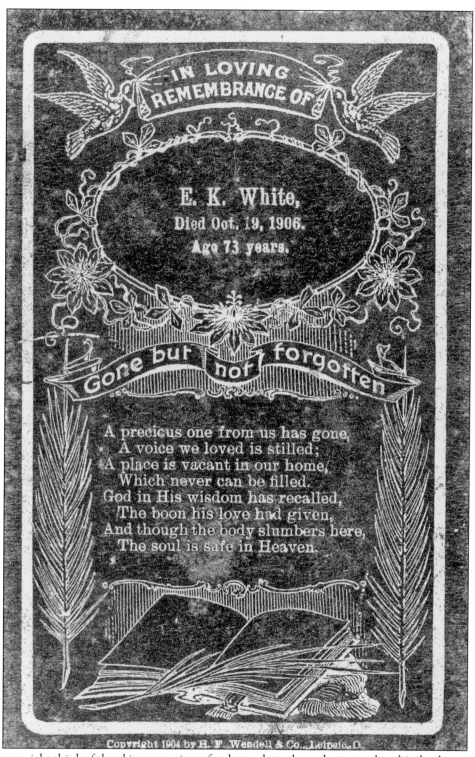

IN LOVING REMEMBRANCE OF

E. K. White,
Died Oct. 19, 1906.
Age 73 years.

Gone but not forgotten

A precious one from us has gone,
A voice we loved is stilled;
A place is vacant in our home,
Which never can be filled.
God in His wisdom has recalled,
The boon his love had given,
And though the body slumbers here,
The soul is safe in Heaven.

Some might think of the obituary notices of today as the only modern ones, but this death notice is just as eloquently written as any contemporary one. (Courtesy John Wilroy.)

With a family that dates back to 1631 in the Drewryville area, Lavina Reynolds Brandon stands with her three children—from left to right, Evelyn Angelyn, Nella Margaret, and Blanche Mae—in the summer of 1914. (Courtesy John and Doris Miller.)

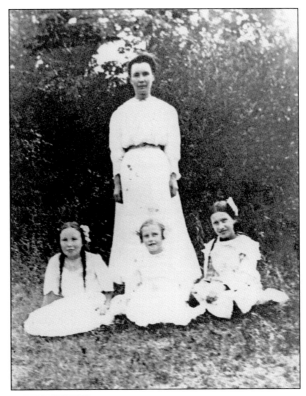

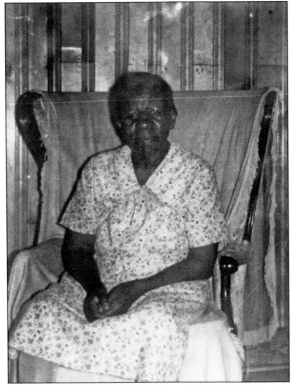

Born in Capron in 1895, Mary Lizzie Jackson Mayfield was the daughter of David and Jennie Julia Jackson Mayfield. She lived there until she married Richard William Rose in 1914. Lizzie and Richard moved to Nansemond County, where he worked both in the Great Dismal Swamp National Wildlife Refuge and at a local rock quarry, and she worked at a local factory. (Courtesy Edwina Morrison.)

Sue Ellen and her mother, Ella Jones of Ivor, stand at their home. (Courtesy Town of Ivor 100th Celebration.)

Bettie Parson (also known as Person), the family matriarch to generations of Persons, was both a farmer and gardener. Known for her tough disposition, she could pick every morsel of cotton from plants, leaving none to waste. (Courtesy Southampton Agriculture and Forestry Museum and Heritage Village.)

Annie Sykes Epps Davis holds her granddaughter, Eleanor Epps, in preparation for a ride to church around 1920. Annie Davis was known for her sewing, as she is seen here modeling her dress with the same fabric adorning her pocketbook. (Courtesy Town of Ivor 100th Celebration.)

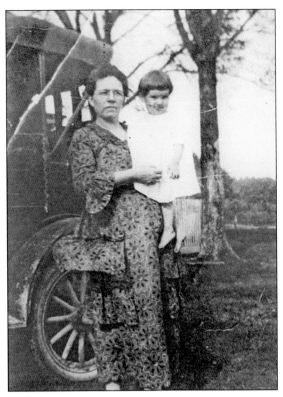

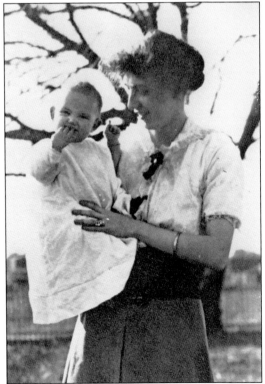

Jessie Brinkley Wilroy shares a private moment with her baby daughter and namesake, Jessie. Both she and her husband, John Wilroy, died when their children were young, and the children lived and were raised by Jesse's relatives in Boykins. (Courtesy John Wilroy.)

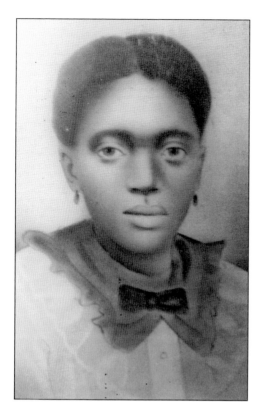

Born about 1857 to Caleb and Hannah Darden, Rosa married farm laborer James Jones, the son of Jack Jones, on February 19, 1890, at her parents' home. In her advanced age, she lived with one of her sons and his family in Franklin. Her favorite pastime was taking her fishing pole with string attached to it, accompanied by her oldest granddaughter, to the local watering hole in an effort to teach her granddaughter how to catch fish. (Courtesy Beatrice Magette.)

Educated at Chowan College, Eva Augusta Person Rawls Ellis (1870–1943) was known for liking her own authority. The fourth child of Junius and Ann Eliza Francis Person, Eva first married Charles Rawls. After his death, she married farmer Benjamin Daniel Ellis. In all, she gave birth to 11 children and used a stern disposition to raise them and to interact with the children in her extended family. "Wipe that lipstick off before kissing me" was one of her refrains. (Courtesy Doris Miller.)

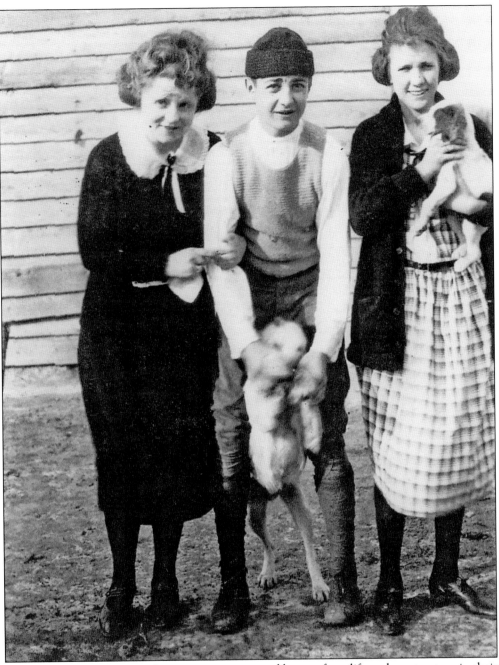

The joys of having sisters and cousins are represented here as farm life took center stage in their lives. From left to right are Reese, Jasper, and "Doots" Wilroy. (Courtesy John Wilroy.)

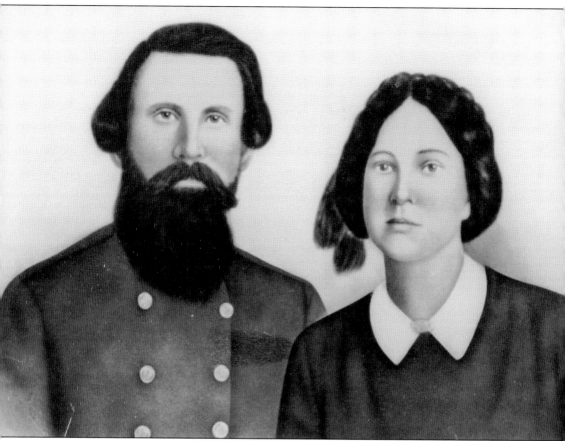

This 1862 wedding portrait is of Junius Randolph (born 1832) and Ann Eliza Francis Person (1838–1884). Randolph attended the University of Virginia, where he studied moral philosophy, ancient languages, and law. He was a Confederate soldier, serving as a first lieutenant in Company G, 3rd Virginia Infantry. He and his wife had four sons and three daughters, all of whom, it is reported, graduated from college. (Courtesy Doris Miller.)

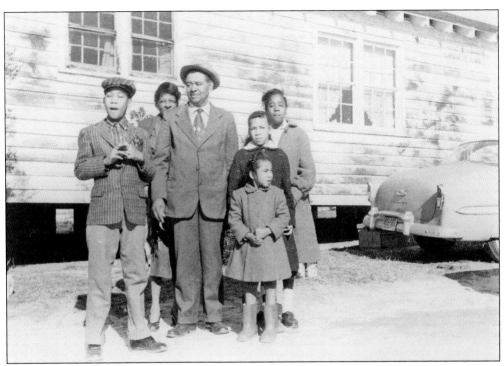

Guy Franklin Claud and his wife, Viola Rogers Claud (behind him), would dress their grandchildren up and take them with them wherever they went. Like many grandparents, they stepped in to take on the role of parents. After the death of one of their daughters, they raised Gwendolyn (far right). (Courtesy Mertle and Obadiah Claud.)

Even in the early 1900s, girls—sisters in this case—just wanted to have some fun by posing on the side of a railcar. (Courtesy John Wilroy.)

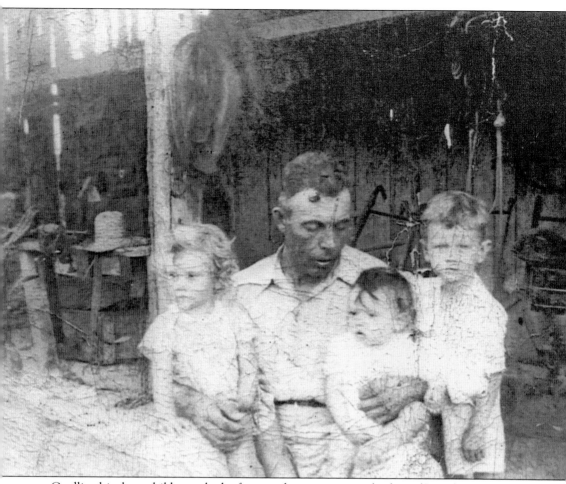

Cradling his three children, a look of utter exhaustion covers the face of David Turner Sr. (born in 1916) after a hard day at work on his farm. He was the son of James T. and Elizabeth Bryant Turner. (Courtesy David Turner Jr.)

Rebecca Capps Wilroy, the wife of John C. Wilroy in Nansemond County, was born in 1869. Her daughters all moved to Southampton, where they married and raised their families. When her husband died, she married their farm's overseer, Robert Brinkley. (Courtesy John Wilroy.)

One daughter of Rebecca Capps and John C. Wilroy was Katherine Marion. Refined and elegant, Katherine married the eligible W. W. White Jr., merchant and son of W. W. White Sr. She and her husband presided over the grandest household in all of Boykins and helped to raise her sister Jessie's son after Jessie's untimely death. (Courtesy John Wilroy.)

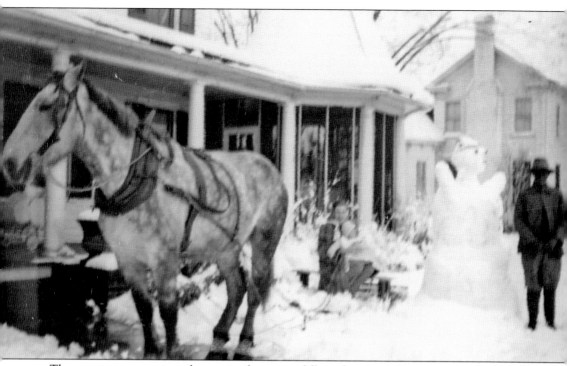

The county was accustomed to getting large snowfalls in the winter. One activity was riding sleds down the hill in Beechwood Cemetery. Horses were efficient in the snow because one could still get around to handle business. This picture was taken about 1945. (Courtesy Kitty Lassiter.)

Part of an old Southampton County family, Elizabeth Bryant Turner (left) poses with her son David Sr., her grandson David Jr., and her daughter-in-law Fannie Bell Pope Turner. Elizabeth was the wife of James Turner, the son of Thomas and Crissie Turner. Her parents were Benjamin and Martha Ellis Bryant. (Courtesy David Turner Jr.)

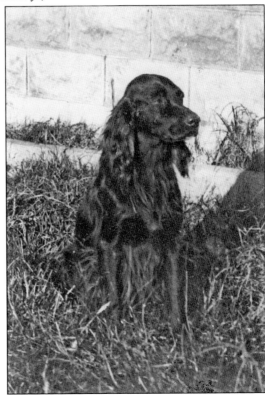

Sparrs, an Irish setter, was one of the well-bred dogs in the Wilroy household. This one belonged to a very young Katherine Wilroy around 1912. Well trained, he often brought Katherine whatever she asked. Katherine's love for dogs may have contributed to her husband's hobby of collecting beautiful dogs once they married in 1920. (Courtesy John Wilroy.)

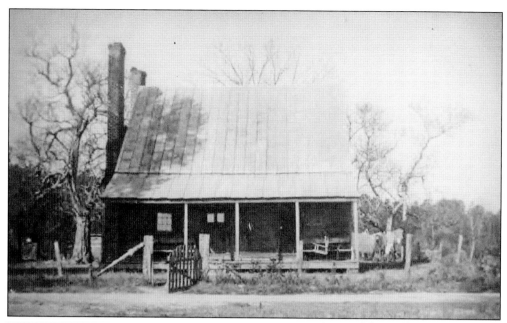

In wood-framed houses much like this one, Southampton County mothers raised their children. The land consisted of a separate kitchen, an outhouse, sometimes a little place to cool butter, and chicken houses. Anna Cobb Scott (born 1876) was one such mother. The daughter of Benjamin Cobb, Anna married Calvin Scott in 1901. Calvin was the son of William and Nancy Scott. (Above courtesy Library of Virginia; left courtesy Southampton Agriculture and Forestry Museum and Heritage Village.)

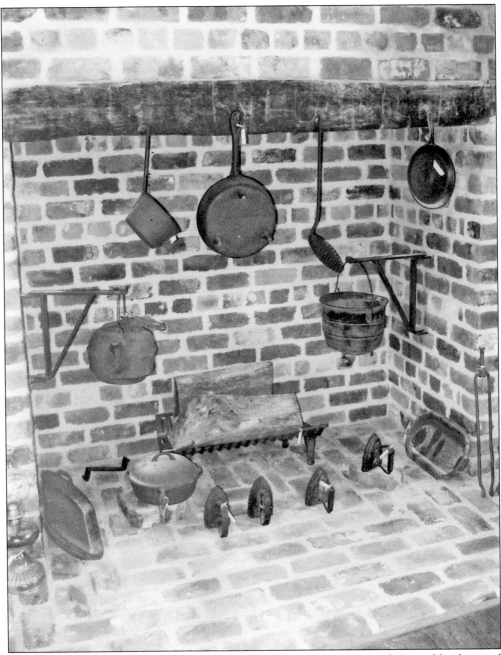

Kitchens were focal points in households just as they are today. Here is the actual kitchen and the utensils used by Anna Cobb Scott in the early 1900s. Notice the even distribution of bricks and perfect placement for firewood. (Courtesy Southampton Agriculture and Forestry Museum and Heritage Village.)

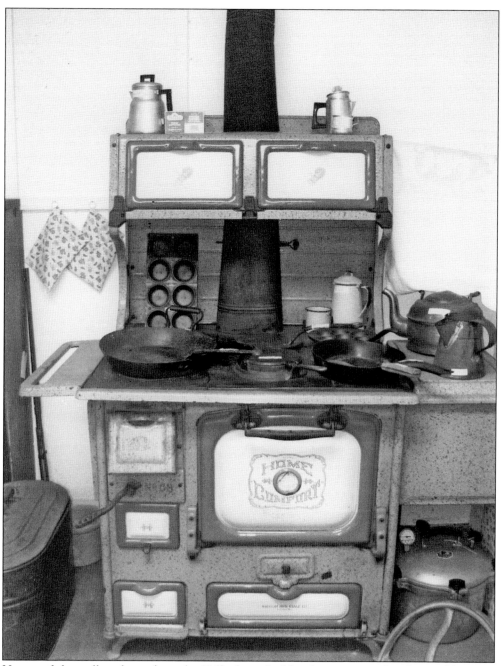

Homes of the well-to-do, such as the Kello farm, had kitchens equipped with wood-burning stoves. This is the actual stove used by the Kello family in the Berlin/Ivor section of the county. (Courtesy Southampton and Forestry Museum and Heritage Village.)

A well-to-do house would also be equipped with a washing machine. This Maytag version has rolling pins that squeeze water from the clothing. The biggest hurdle was ensuring children's fingers did not get caught between the rollers. (Courtesy Boykins Museum.)

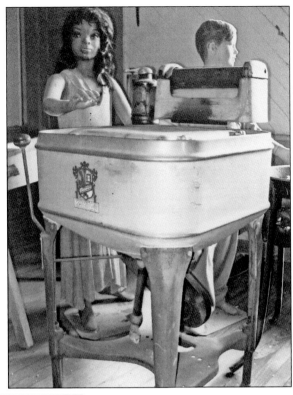

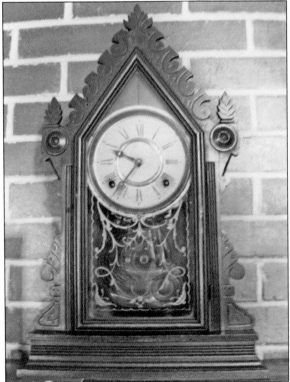

This all-wood, hand-carved, wind-up alarm clock has been in the Barker family for more than 100 years and still keeps perfect time. (Courtesy Frederick Barker Jr.)

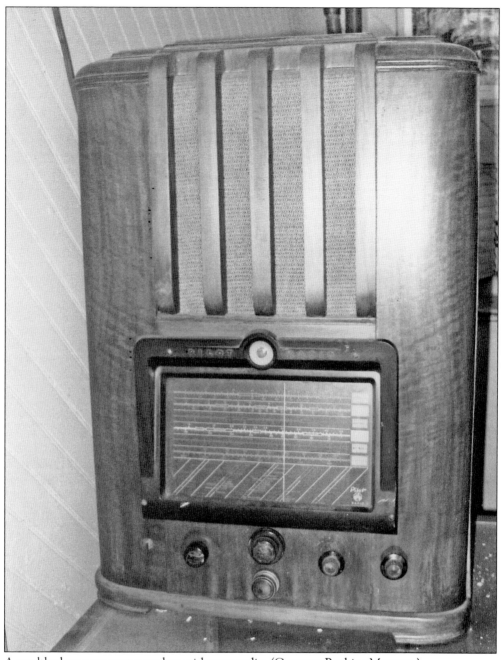

A wealthy home was not complete without a radio. (Courtesy Boykins Museum.)

This patch from a friendship quilt was made by local women before the Civil War. It was presented to Sallie R. Edwards in 1940 in memory of Rebecca E. Murphy Wood Williams, the mother of Pink Wood, Laura Williams, and Helen Williams. (Courtesy Richard Spier Edwards Jr.)

Ruth Batten Cobb Rawls was the wife of farmer, merchant, and pharmacist Willie C. Rawls, and she helped her husband in his store. She attended Farmville State Teachers College and was known throughout the county for her beauty and culture. In their home designed by her husband, Ruth tended her garden, and she had a special love for camellias. (Photograph, 1912; courtesy Town of Ivor 100th Celebration.)

Born in 1892, the quiet and dignified Henry Gordon Coleman was often called "a true gentleman." Originally from Gordontown, North Carolina, he became a railroad agent. In 1913, he married Edna Earle Powell, the daughter of W. A. Powell of Powell Packing Company. (Courtesy Southampton Agricultural and Forestry Museum and Heritage Village.)

Saint Paul Wellons grew up farming, but when he got older, he developed his trade as a barber. Here he is posing with several of his 11 children. He believed there was no excuse to not dress well and was known for always having his shirt tucked in. (Courtesy Ruth Wellons Lane.)

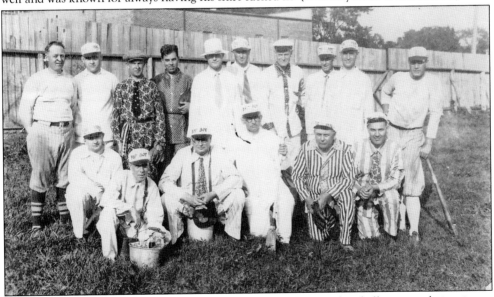

In 1926, the Franklin Rotary Club (pictured) played a fund-raising baseball game in their pajamas against the Ivor Ruritan Club, clad in bib overalls. The Rotarians lost the game. From left to right are (first row) George Parker, Joe King, S. W. Rawls, Paul Scarborough, Dr. E. A. DeBordnave, and N. C. Barbour; (second row) ? Chapman, J. E. Moyler, Edgar Fitzgerald, Franklin Edwards, George Watkins, F. F. Jenkins, B. J. Ray, unidentified, John C. Parker, and J. W. B. Thompson. (Courtesy Walter Cecil Rawls Memorial Library.)

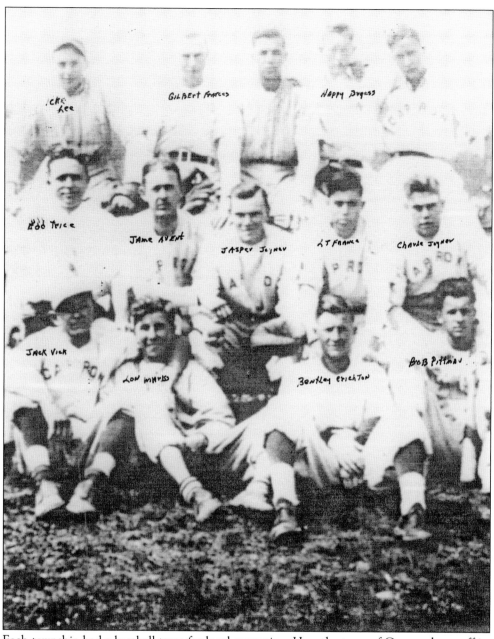

Each township had a baseball team for local recreation. Here the town of Capron shows off its team. (Courtesy Ira "Pete" Barham.)

After a day of hunting, the locals came back with a six-point deer. From left to right are Sammy Williams, Moses Wyche, Dashland Barham, Elijah Wyche, Hugh Wyche, Butler Wyche, and Frank Williams. (Courtesy of Ira "Pete" Barham.)

Local hunt clubs formed in the early 1920s and carried on with the weekly tradition of hunting together in the thick woods of the county. Here they are experiencing the joy of getting an eight-point deer. (Courtesy Kitty Lassiter.)

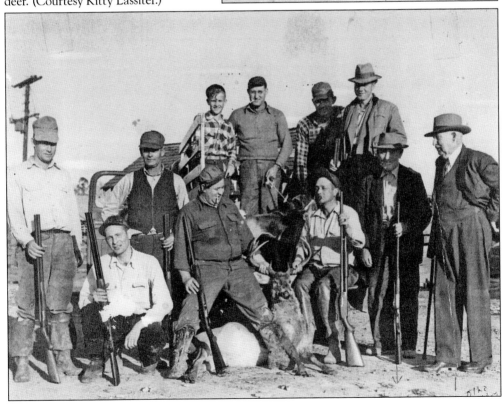

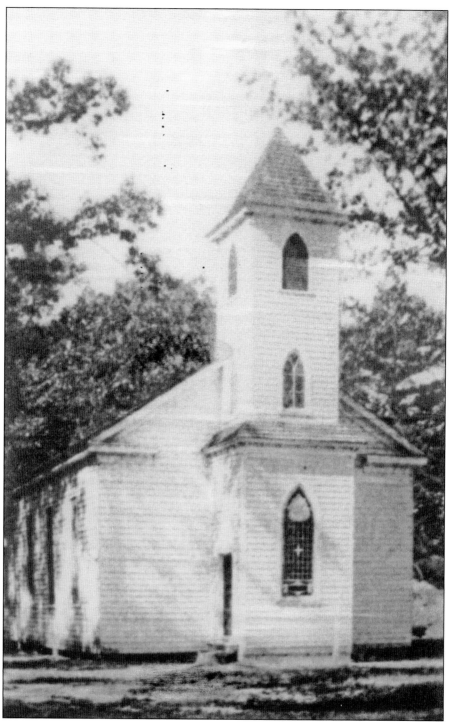

Religious life cannot be ignored, even though it did not pay a seminal role in the county. It did, however, play an important social role. From Methodist to Baptist to Episcopal and even Quaker meetinghouses, church members carried news near and far throughout the county. Here was the first Methodist church in Ivor. (Courtesy Town of Ivor 100th Celebration.)

Rev. A. E. Owens of Hebron Baptist Church presided when the Native Americans and African Americans who attended there decided to form a church of their own in the mid-1860s. They gathered, left, and formed Rising Star Baptist Church three miles down the road from Hebron. (Courtesy Hebron Baptist Church.)

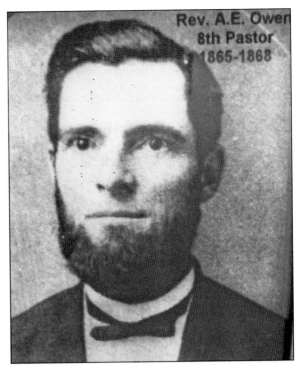

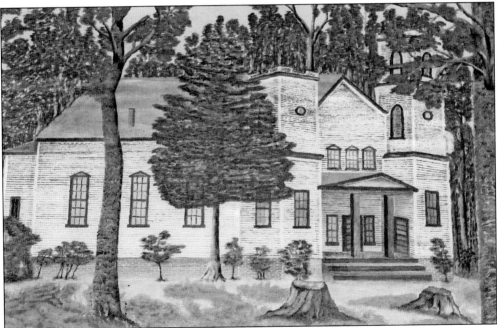

At the outbreak of the Civil War, African American members of Tucker Swamp Baptist Church were no longer welcome. They left and soon formed Little Gilfield Baptist Church on land donated by William and Ann Eliza Diggs. Across the field was the Rawls estate, where a young Walter Cecil Rawls admired the church on a hill in a grove of trees. He painted the church in oils and presented it to the congregation in 1952. He had such respect for the church that he gifted the congregation $1,000 upon his death. (Photograph by Terry Miller.)

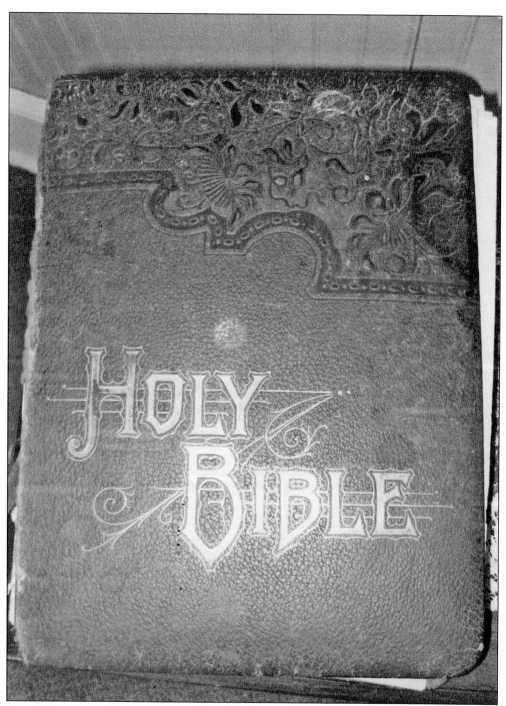

One of the most precious possessions of any church is its original pulpit bible. Here is the 1898 bible belonging to Persons United Methodist Church. It was one of the items saved when the church burned to the ground in 1902. The congregation was given another pulpit bible signed on June 19, 1938, by Southampton County native, attorney, U.S. congressman, and later Virginia governor Colgate Darden Jr. and his wife, Constance. (Courtesy Persons United Methodist Church.)

Tom Zollicoffer was born in Halifax County, North Carolina, in 1857. By 1880, he was married to Adline, was literate, and was farming. In the early 1880s, he proclaimed his call to become a Baptist minister and founded Mount Tabor Baptist Church in Newsoms. He and his wife had eight known children. After his death, his oldest son, Marion, became the senior pastor of Mount Tabor. (Courtesy Mount Tabor Baptist Church.)

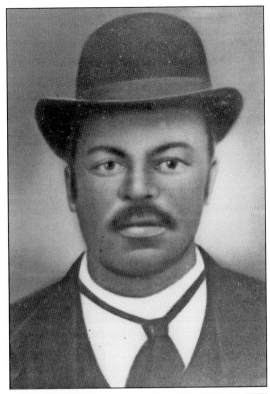

Churches have different architecture and symbols. Worshippers are all reminded that they are one body. Here in the Boykins Methodist Church is a Star of David memorial window. The church was organized on July 29, 1883, with approximately 55 members. Their original building was complete and dedicated for service in September 1884. (Photograph by Terry Miller.)

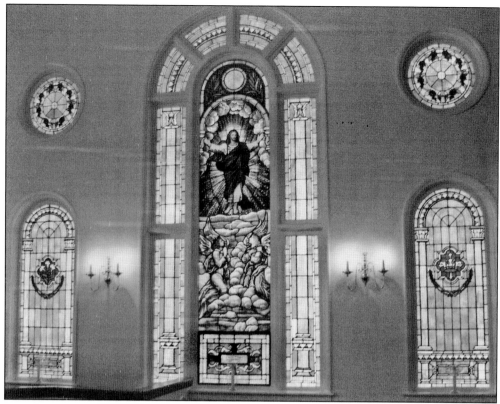

Boykins Baptist Church has the distinction of owning the last set of stained-glass windows that left Europe before the start of World War I. (Photograph by Terry Miller.)

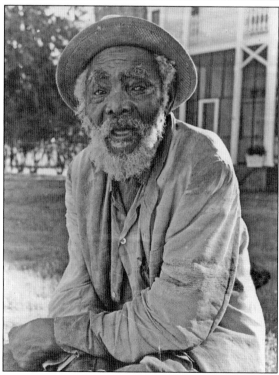

Mack Powell (born 1893) was the son of Wyatt Powell and Hester Day. He married Hattie Artis, the daughter of David Artis and Caroline Harris, in 1926. They had one known child, Annie. Powell worked on farms throughout Boykins and Branchville and regularly frequented a stoop in Boykins. He caught the eye of a Chowan College student photographer, who took his picture. The beauty of Powell's old age captured on film made the young photographer's career. This photograph was taken by Boykins' own Kitty Lassiter. (Courtesy Kitty Lassiter.)

Before Boykins Methodist moved into its new sanctuary, the congregation worshipped in this church building. It was bought by the black Baptists who, in 1909 (the date of this photograph), broke away from the original Bethel church, the predecessor to Shiloh Baptist Church. The name of the original Methodist building was changed to New Bethel, and it became the newest Baptist congregation in Boykins serving the black population. (Courtesy Kitty Lassiter.)

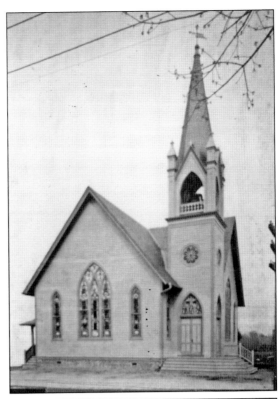

Worshippers hold communion sacred, and here is the original communion set of Shiloh Baptist Church. The casing is wood, the glass is lead, and the set is inscribed with its origin, Toronto, Canada. (Photograph by Terry Miller.)

Churches have organs, and this one is dramatic in its carved, wooden beauty. It was the original organ of Hebron Baptist Church, the oldest known organized church in Southampton, dating to 1786. (Photograph by Terry Miller.)

Churches have different seating arrangements depending on if you are a layperson, deacon, or visiting minister. Standard wooden pews were always used for the rank-and-file worshipper, while the more elegantly carved and cushioned chaises were in a separate section of the church for visitors. (Photographs by Terry Miller.)

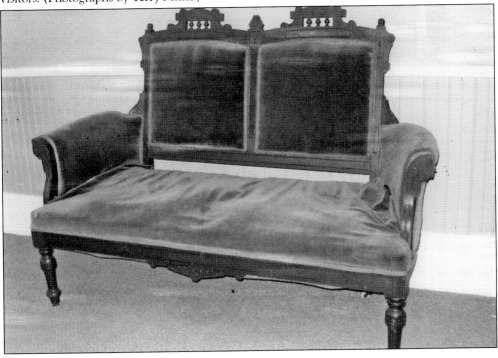

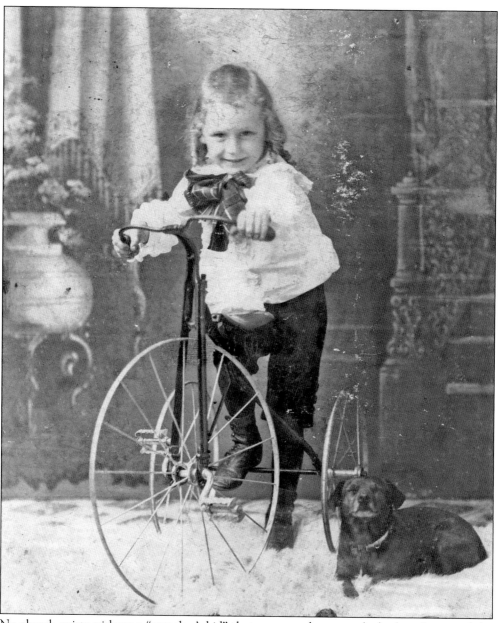

No church exists without a "preacher's kid" that everyone knows and who has the run of the church. Paul Crenshaw Colonna was the son of Rev. Major S. Colonna, who served as pastor of Boykins United Methodist Church from 1894 to 1898. (Courtesy Kitty Lassiter.)

Essie Edwards Grizzard, married to William Henry Grizzard, was born on October 28, 1880. She and her husband had 11 children, and she is representative of women who, like their husbands, farmed to ensure the children were fed before they were. (Courtesy Doris Miller.)

William Henry Grizzard, husband to Essie Edwards, was born on April 27, 1876. A farmer from sunup to sundown, Henry and Essie married on March 27, 1899. He died in 1943 (she lived until 1957). (Courtesy Doris Miller.)

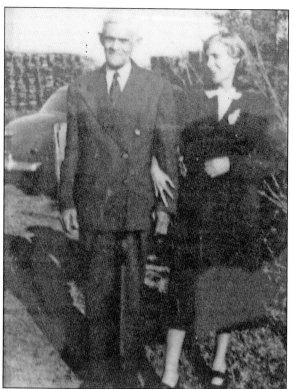

Husband and wife Joe Alley and Marcia Eloise Mason Turner were wealthy planters who also made their money in other enterprises. Joe was the oldest son of logging magnate Walter Turner. (Courtesy Lynette Allston.)

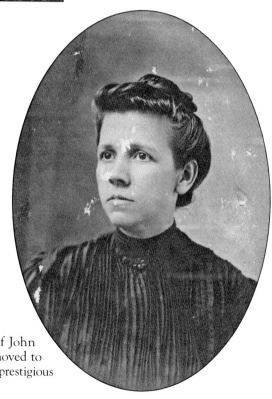

Grace Wilroy was the oldest daughter of John Wilroy and Rebecca Capps Wilroy. She moved to Southampton County and married into the prestigious Pope family. (Courtesy John Wilroy.)

Joseph Newton and Annie Ricks were the first couple to marry in Persons United Methodist Church after it was rebuilt in 1903, following a devastating fire that began with a spark from a wood stove. Their children are, from left to right, (seated) Otelia, Lee, and Bernice Rebecca; (standing) Lula and Charlie. Both Joseph and Annie were communion stewards at Persons United Methodist Church. Annie wore white gloves and put flowers, usually from her own garden, on the pulpit weekly. (Courtesy Marie Beale Turner.)

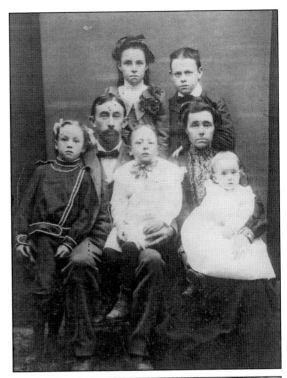

Jackye Holland, the third daughter of Dr. Ernell and Roswell Holland, liked to play on her grandfather Frank's car. Here she is caught. Called "Ol' Doc," Dr. Frank Napoleon Harris moved to Franklin and established his medical practice in 1911. He was the first African American doctor to practice in Franklin. (Courtesy Terrie Smith.)

There is a difference in the toys and gifts children receive based on socioeconomic status. This Little Black Sambo pocket watch was a gift to a well-to-do child in the county. The watch still keeps perfect time and is a collector's item. (Courtesy Southampton Agriculture and Forestry Museum and Heritage Village.)

This black doll was handmade by a slave around 1850 and given to one of her children to play with. Even though it seems primitive in character, it is instructive on how slaves used available materials to fashion a toy for their own children to enjoy. (Courtesy Southampton Agriculture and Forestry Museum and Heritage Village.)

There are pets, and there are pets. This parrot was the pet in the W. W. White household, and its name really was Polly, and it really did say loudly, "Polly wants a cracker," well into the night. (Courtesy John Wilroy.)

ACROSS AMERICA, PEOPLE ARE DISCOVERING
SOMETHING WONDERFUL. THEIR HERITAGE.

Arcadia Publishing is the leading local history publisher in the United States. With more than 5,000 titles in print and hundreds of new titles released every year, Arcadia has extensive specialized experience chronicling the history of communities and celebrating America's hidden stories, bringing to life the people, places, and events from the past. To discover the history of other communities across the nation, please visit:

www.arcadiapublishing.com

Customized search tools allow you to find regional history books about the town where you grew up, the cities where your friends and family live, the town where your parents met, or even that retirement spot you've been dreaming about.